IMAGES
of America

THE GEORGIA
AIR NATIONAL GUARD

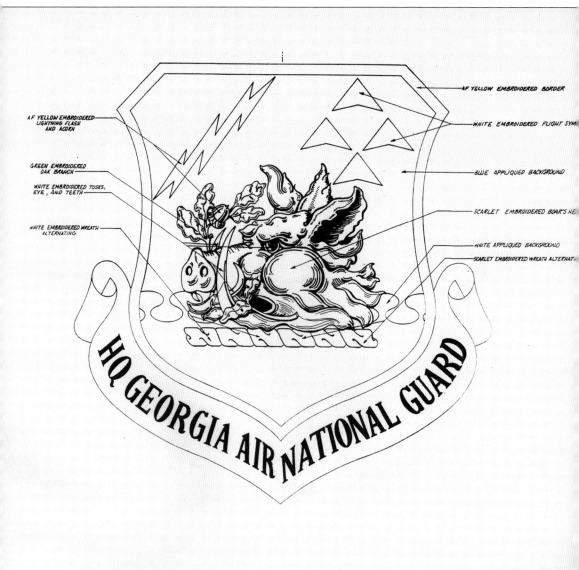

The Headquarters, Georgia Air National Guard emblem was approved by the Air Force Historical Research Agency on March 12, 1992. The emblem incorporates the colors of blue and yellow. Blue alludes to the sky, the primary theater of Air Force operations. Yellow refers to the sun and the excellence required of Air Force personnel. The boar's head on the wreath is the crest for the Georgia Air National Guard and reflects the unit's heritage. The lightning flash symbolizes communications units. The flight symbols in formation denote the flying units of the Headquarters. (Courtesy of the Historical Society of the Georgia National Guard.)

ON THE COVER: F-51H flightline operations are pictured at Travis Field Summer Camp in Savannah, Georgia, in the summer of 1953. The 128th Fighter Bomber Squadron was assigned five F-51H Mustangs. The unit borrowed additional Mustangs from another squadron to complete a productive two weeks of training. (Courtesy of the Historical Society of the Georgia National Guard.)

IMAGES
of America

THE GEORGIA AIR NATIONAL GUARD

Clint Smith

Copyright © 2024 by Clint Smith
ISBN 978-1-4671-6105-3

Published by Arcadia Publishing
Charleston, South Carolina

Printed in the United States of America

Library of Congress Control Number: 2023947606

For all general information, please contact Arcadia Publishing:
Telephone 843-853-2070
Fax 843-853-0044
E-mail sales@arcadiapublishing.com

Visit us on the Internet at www.arcadiapublishing.com

This book is dedicated to all past, current, and future members of the Georgia Air National Guard, including airmen who made the ultimate sacrifice.

CONTENTS

Acknowledgments		6
Introduction		7
1.	The Early Years	11
2.	Coastal Georgia	21
3.	The Korean Conflict Era	29
4.	Important Aircraft	39
5.	The 1960s and 1970s	53
6.	The 1980s and 1990s	75
7.	Post 9/11	91
Bibliography		127

ACKNOWLEDGMENTS

My thanks, appreciation, and admiration are extended to many people for their sincere desire to preserve and document the history of the Georgia Air National Guard as well as educate the public on the organization's past and its critical importance presently and in the future. Sadly, several friends who played a great role in preserving the organization's history have passed away. Col. Bill Ridley Jr. was a very active member of the Historical Society of the Georgia National Guard and was instrumental in preserving and documenting the history of the 116th Air Control Wing as well as contributing most of his personal collection of artifacts, photographs, and documents to the historical society. Col. Ed Wexler was active in documenting the 165th Airlift Wing's history and other military historical subjects on the coast of Georgia. Brig. Gen. Tom Dalton from the Army side of the Georgia National Guard family was the president of the historical society for many years. He was also very influential in supporting public policy issues for the Georgia National Guard at the Georgia State Capitol in Atlanta. Special appreciation must be expressed to all the board of directors members and leaders, Army, Air, retired, and civilian, of the Historical Society of the Georgia National Guard who volunteered countless hours to document Georgia National Guard history. Accolades go out to another Army National Guardsman, Maj. William Carraway. He serves as the command historian for the Georgia Army National Guard. However, he has demonstrated great support for the Air Guard as well. Many of his social media and blog posts have featured Air Guard history subjects. I worked with public affairs officer Col. Ken Baldowski (Ret.) for many years at State Headquarters, Georgia Air National Guard. He is a friend who understood the importance of the history program and supported it as much as possible in his duties. Col. Dan Zachman (Ret.), who I worked with at Headquarters, has always been an enthusiastic student of military history. The deputy adjutant general of the Georgia National Guard, Joe Ferrero, a longtime friend, is a strong advocate of promoting Air National Guard history. My heartfelt thanks go out to my editor at Arcadia Publishing, Caroline (Anderson) Vickerson, for her support and expertise. I want to express my love and respect for my late parents, Charles (a World War II Navy veteran) and Evelyn Smith, who inspired me to pursue goals that contribute to society as a member of the military and in my civilian life. My love and appreciation are emphatically extended to my wife, Cammie, who has been patient, understanding, and supportive as I pursued this book project. Finally, I acknowledge that I have been blessed by God in so many ways, especially because of the love, grace, and salvation that I experience through His Son Jesus Christ.

INTRODUCTION

The origin of the National Guard can be traced back to the arrival of the first English settlers. These settlers and those in future communities relied on militia units and volunteers for defense in America. An organized militia was first created on December 13, 1636, when the leaders of the Massachusetts Bay Colony ordered that all males between the ages of 16 and 60 own firearms and form into three regiments. These early militia personnel drilled once a week and provided security in the evening for the community. The threat of the Pequot Indians to the Massachusetts Bay Colony necessitated organized forces. The colonial militias were organized around three central concepts: a universal service obligation for able-bodied European males, short periods of active duty service to deal with serious threats, and territorial and time limits on service.

The first muster of the East Regiment took place in Salem, Massachusetts, in 1637. The musters served three essential purposes: training, inspecting the arms and equipment of individual militiamen, and determining the availability of specific numbers of men and their individual abilities. Training became less intense as the frontier and associated Indian threats gravitated to the west.

Georgia's military history dates back to England in the early 1730s. A group of businessmen, including Gen. James Edward Oglethorpe, suggested that a fortified military academy was in order to protect the southern frontier of South Carolina from enemy attacks. In 1732, a board of trustees that included 21 English businessmen, including Oglethorpe, was established to sponsor the colony.

Potential settlers to the new colony of Georgia were screened, and eventually 35 families were invited to join the adventure to America led by Oglethorpe. He announced that male colonists must be stable married men between the ages of 17 and 45 and that they agree to serve as militia in the colony.

"The soldiers hold the spade in one hand and the sword in the other and both successfully," Oglethorpe said. In the second half of 1732, the men received instruction in drill every day from the Sergeants of the Guard in London.

The trustees were granted a royal charter for the colony of Georgia by King George II on March 21, 1732. The original militia, the forerunner of today's Georgia National Guard, first displayed courage and ability less than 10 years after settling Georgia.

On July 7, 1742, General Oglethorpe's militia, along with British Regular troops, was called to action to drive Spanish invaders from the colony's shores at the Battle of Bloody Marsh, as it came to be known. The contingent of 900 militiamen, Regulars, and Native Americans courageously held their position while Oglethorpe traveled to Fort Frederica for reinforcements. With a new group of troops, the Georgians were able to force the Spanish to retreat. The Battle of Bloody Marsh was the turning point in the war with the Spaniards over possession of Georgia's land.

During the Revolutionary War, the 1st Brigade Georgia Militia, the state's original minutemen, was raised for service with the Continental Army under Gen. George Washington to secure American independence. In 1778, British soldiers approached Fort Morris and demanded surrender. Gen. John McIntosh responded to their request with the following pronouncement that has been a source of pride and inspiration for Georgia Army National Guardsmen through the years. "We

would rather perish in a vigorous defense than accept your proposal, sir," wrote McIntosh. "We, sir, are fighting the battle of America and therefore disdain to remain neutral 'til its fate is determined. As to surrendering the fort, receive this reply: Come and take it!" British troops withdrew, and McIntosh was honored as a hero in Georgia.

On February 14, 1779, Georgia militiamen engaged in one of the most important battles of the Revolutionary War. It was known as the Battle of Kettle Creek. Weakened and disillusioned, the British evacuated Savannah on July 11, 1782. Georgia became the fourth state in the new union on January 2, 1788.

The National Guard's presence as a force in the fledgling concept of aerial warfare can be traced to the First Aero Company, Signal Corps, New York National Guard. It was officially formed on May 30, 1908. It should be noted that this milestone predates the well scrutinized and successful effort by the Wright brothers to convince the US Army that the airplane could contribute to military missions. The First Aero Company consisted of 25 aviation enthusiasts who had volunteered to learn ballooning. Within two years, the unit had financed its first aircraft. It cost approximately $500.

During World War I, the development of National Guard aviation assets was very limited. In fact, in April 1917, the US War Department decided that National Guard aviation units would not be mobilized. The units were disbanded, and many of the members volunteered for active duty. After the war, the National Guard was reorganized. Several influential Army Air officers, including Brig. Gen. Billy Mitchell, pushed hard for "aero units" to be included in National Guard infantry divisions. The availability of over 8,000 surplus World War I aircraft proved one of the deciding factors in support of the plan. By 1930, the National Guard was outgrowing its initial presence of only divisional observation squadrons to become separate and distinct units. In fact, official documents list its members as "Corps Aviation Troops."

In September 1940, much of the National Guard was ordered into federal service. Some of the aviation units retained their numeral designations, but eventually, as US involvement in World War II developed, most of the units' personnel were dispersed across the expanding Army Air Corps as individuals instead of as members of organized National Guard units.

The politics of postwar planning led to the eventual official creation of the Air National Guard as a separate reserve component of the US military. The overarching position by many in the military and civilian elected officials and others to create a separate active duty Air Force military component, breaking away from aviation assets in the active duty Army, was a major factor.

In April 1946, the 120th Fighter Squadron in Denver, Colorado, was activated. It is considered to be the first separate Air National Guard unit in the country. A total of 541 Air National Guard units would be allotted to the various states. Two Georgia units were soon established. Headquarters, 116th Fighter Group was activated on September 9, 1946, and Headquarters, 54th Fighter Wing was activated on October 6, 1946.

Many twists and turns in the legislative process in Washington, DC, concluded with the National Security Act of 1947. It was comprehensive legislation that changed the US military in many ways. (Please refer to the bibliography for books that focus in greater detail on this period in US military history). Pres. Harry Truman signed the National Security Act of 1947 (Public Law 253) after the US Congress passed the legislation that created the US Air Force as a separate active duty military component effective September 18, 1947. On this day, the Air Force became the gaining service for the bomber and fighter squadrons of the National Guard. These squadrons, as well as the supporting units, comprised what was officially a separate reserve military component—the Air National Guard. Thus, September 18, 1947, is considered the birthday of the US Air Force and the Air National Guard. (The official birthday of the US Air Force Reserve is April 14, 1948.)

In fiscal year 1948, sixteen squadrons were extended federal recognition: nine with Mustang aircraft, five with Thunderbolt aircraft, and two with Invader aircraft. These units were located in 11 states and Puerto Rico and elevated the Air National Guard to a total strength of 73 mission squadrons and 320 support units. In 1948, the Air National Guard entered the jet age. The first order of 60 Lockheed Shooting Stars was delivered to five fighter squadrons, including the 158th Fighter Squadron in Savannah, Georgia.

Headquarters, Georgia Air National Guard received federal recognition by the National Guard Bureau on January 1, 1952. On February 2, 1955, Gov. Marvin Griffin signed into law the Georgia Military Forces Reorganization Act of 1955, which established a senior officer leadership structure for Headquarters. The mission of the Headquarters unit is to support the commander in the command, control, and direction of the Georgia Air National Guard; in providing combat ready units to the US Department of Defense; and with military capability to the state of Georgia. The unit was originally located at 935 East Confederate Avenue, Atlanta, Georgia. In January 1997, the unit moved to the MG George G. Finch Building at Dobbins Air Reserve Base, Marietta, Georgia. Currently, Headquarters is located at the Clay National Guard Center in Marietta, Georgia.

Special recognition is extended to the following Georgia Air National Guardsmen who lost their lives in service to the state of Georgia and our nation: Capt. Donald R. Harris, 1942; Capt. John R. "Pat" Turner Jr., 1943; TSgt. J.B. Grogan, 1943; TSgt. Thomas L. Johnson, 1943; SSgt. Edward W. Simpson, 1943; 2nd Lt. James L. Baird, 1948; 1st Lt. Allen F. Colley, 1948; 2nd Lt. William O. Colley, 1948; Capt. Jerome A. Klausman, 1948; 1st Lt. William F. Scarborough, 1948; 2nd Lt. William C. Garner, 1949; Capt. Daniel L. Womack, 1949; 1st Lt. Kenneth M. Goodrum, 1950; 1st Lt. Tom A. Martin, 1950; SSgt. James A. McKay, 1950; Capt. Barney P. Casteel, 1952; Capt. David J. Mather, 1952; Capt. John F. Thompson, 1952; 1st Lt. James L. Collins, 1952; Capt. William Manke, 1952; Lt. Col Walter M. Armistead, 1953; Capt. Idon M. Hodge Jr., 1953; 1st Lt. Samuel P. Dixon, 1953; 1st Lt. Elwood C. Kent, 1953; 2nd Lt. William A. Tennant, 1953; 1st Lt. Robert A. Barr, 1956; 1st Lt. James S. Bonner, 1956; Capt. David G. Hammond, 1983; Capt. James L. Steakley, 1983; Lt. Marvin D. Barfield, 1948; Lt. Louie A. Mikel, 1948; Lt. Henry O. Thompson Jr., 1948; Capt. Carl H. Oelschig Jr., 1951; Lt. Will C. White, 1951; Lt. Frank B. Jackson, 1951; Lt. Col. Earl C. Brushwood, 1954; Capt. Edward A. Woodard Jr., 1957; Maj. William G. Goggans Jr., 1970; Maj. Paul R. Jones, 1970; Lt. Bobby B. Bowen, 1970; MSgt. Wesley E. Vaughn, 1970; MSgt. Carl J. Worrell, 1970; TSgt. Charlton L. Cohen, 1970; SSgt. Thomas Fogle, 1970; and 1st Lt. Robert M. Schuller, 1982.

One

THE EARLY YEARS

In 1940, Belgium, Denmark, France, Norway, and several other nations fell to Nazi Germany invasions. The United States was in war preparation mode. 2nd Lt. Chas M. Ford Jr., deputy city clerk for the City of Atlanta, wrote a letter to the National Guard Bureau inquiring about the possibility of Georgia being granted an Air Corps squadron. On February 14, 1941, the chief of the National Guard Bureau granted authority to the adjutant general of Georgia to organize the 128th Observation Squadron. Gov. Ed Rivers asked George G. Finch, a distinguished Atlanta attorney and former Air Corps flyer, to organize the first flying unit. The unit was dubbed "Atlanta's Own." The first member to sign up was attorney James G. Grizzard. Soon thereafter, five Delta Airlines employees—four aircraft mechanics and a radio operator—were enlisted. Nick Vlass was crew chief on the unit's first aircraft, a BC-1A.

The 128th Observation Squadron was federally recognized on May 1, 1941, as a unit in the Georgia National Guard. The new members assembled in the Ansley Hotel in Atlanta for a swearing-in ceremony. George Finch was commissioned as a major and assumed command of the squadron. The weekly training was conducted at Candler Field Municipal Airport in Atlanta and at the National Guard Armory located on East Confederate Avenue.

The squadron was equipped with one North American BC-1A, one Douglas O-46A observation plane, and one Douglas OZ-38E biplane. Pilots were equipped with several aerial cameras, but wheeled vehicles to support the mission were in short supply.

On September 15, 1941, the 128th Observation Squadron consisted of 102 enlisted men and 16 officers when it was officially inducted into the Army of the United States at Candler Field.

Eventually, the unit was assigned to the Second Air Support Command at Will Rogers Field, Oklahoma. The squadron itself was assigned to Lawson Field, Fort Benning, Georgia.

The 128th Observation Squadron arrived at Lawson Field with three aircraft. Major Finch changed the low inventory situation. The base commander agreed to transfer several mechanically challenged aircraft to Finch's squadron. They gave the aircraft a complete overhaul.

On December 7, 1941, the Japanese attacked Pearl Harbor. There were 29 National Guard observation squadrons on active duty and all were placed on full war alert. Since enemy submarines off the US coast presented a greater threat, the squadrons were retained on submarine patrol.

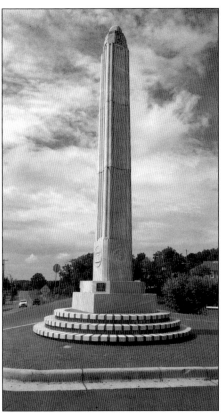

This monument to Gen. James Edward Oglethorpe is located in Jasper, Georgia. It was designed and dedicated in 1930 by Col. Sam Tate of the Georgia Marble Company. It was carved by James Watt from Cherokee marble that was quarried locally. Originally, the monument was located 10 miles east on Mount Oglethorpe (Grassy Knob), the southern terminus of the Appalachian Trail until 1958. It was restored and moved to its current location in 1999. (Author's collection.)

The location of the Battle of Bloody Marsh is marked by this monument. It was the turning point in the war with the Spaniards over possession of Georgia's land. When the Spanish stopped to rest in a low-lying swamp, Oglethorpe and his men ambushed them. The small fight had a profound impact. After the battle, Spanish presence in North America was confined to Florida, California, and parts of the Southwest. (Author's collection.)

General Oglethorpe traveled to Fort Frederica for reinforcements during the Battle of Bloody Marsh. Fort Frederica was established in 1736 by Oglethorpe to protect the southern boundary of the new colony of Georgia from the Spanish in Florida. Named for Frederick Louis, the prince of Wales (1702–1754), Frederica was a military outpost consisting of a fort and town. The entire area was fortified with a palisade wall and earthen rampart. The fort's location on the Frederica River allowed it to control ship travel. (Author's collection.)

Members of the 128th Observation Squadron assembled at the Ansley Hotel in Atlanta for swearing in ceremonies. The hotel was built in 1913 by Edwin P. Ansley, who also developed Ansley Park. The building was located on the 100 block of Forsyth Street. In 1953, the Ansley was sold to the Dinkler hotel chain and was renamed the Dinkler Plaza Hotel. (Courtesy of the Historical Society of the Georgia National Guard.)

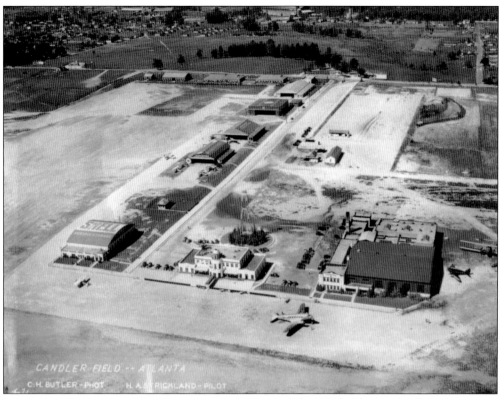

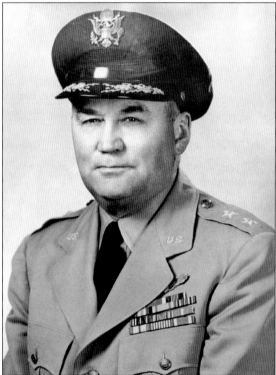

The 128th Observation Squadron conducted biweekly training at Candler Field Municipal Airport in Atlanta. Most of the activity was carried out at the Army hangar at the north end of the ramp. The old Hangar Hotel furnished government contracted meals for the unit. Additional training took place at the National Guard Armory on East Confederate Avenue in Atlanta. (Courtesy of the Historical Society of the Georgia National Guard.)

A former Air Corps flyer, Maj. Gen. George G. Finch organized the first flying unit of the Georgia National Guard at the request of Gov. Ed Rivers. Soon thereafter, he was commissioned a major and assumed command of the organization on May 1, 1941. Later, he was the first commander of the 54th Fighter Wing and the commander of 14th Air Force. (Courtesy of the Historical Society of the Georgia National Guard.)

Brig. Gen. Charles S. Thompson was an original member of the 128th Observation Squadron. He commanded the 81st Bomb Squadron and 12th Bomb Group in World War II. Later, he was appointed commander of the 116th Military Airlift Wing where he ushered in the C-124 Globemaster era (1966–1974). (Courtesy of the Historical Society of the Georgia National Guard.)

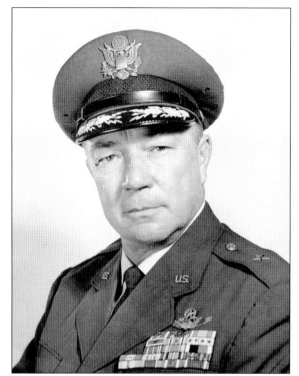

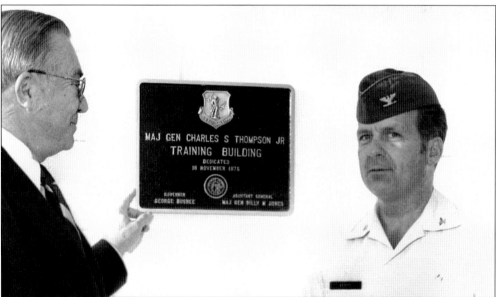

Maj. Gen. Charles Thompson (left) poses with Col. William Berry (right) at Dobbins Air Force Base on November 16, 1975. The new training building was named in Thompson's honor. In 1971, General Thompson was confirmed by the Senate of the United States to the rank of major general and transferred to Headquarters, Georgia Air National Guard as chief of staff. He was the first line officer to attain this rank in the history of the Georgia Air Guard. During his career, Thompson flew 21 types of aircraft and logged over 7,000 hours of flying time. (Courtesy of the Historical Society of the Georgia National Guard.)

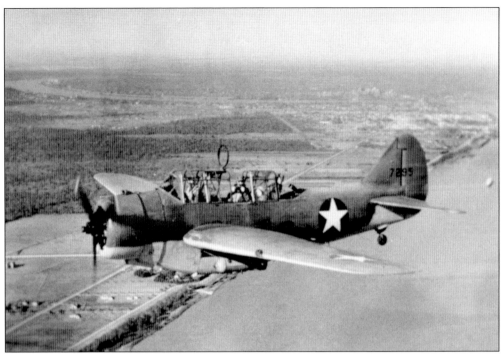

The O-47A aircraft were flown by the 128th Observation Squadron beginning in the summer of 1942. Later, the unit participated in anti-submarine missions using this aircraft. In one incident, the pilot shot .30-caliber ammo at the sub but to no avail. Afterward, the O-47As were fitted with bomb racks to carry 325-pound depth charges plus two .30-caliber machine guns. (Courtesy of the Historical Society of the Georgia National Guard.)

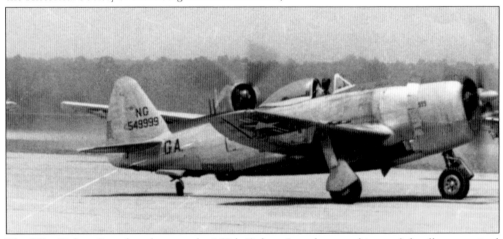

The 351st Fighter Squadron became the 158th Fighter Squadron, and it was federally recognized and assigned to the 116th Fighter Group on October 13, 1946. It was stationed at Chatham Field in Savannah, Georgia. This P-47D was part of its original fleet of aircraft. The P-47D was nicknamed the "Jug." Two theories exist as to the origin of the moniker. Some claim that it was tagged with the nickname because the fuselage looked like a traditionally shaped milk jug. Others claim that the nickname was given by the British for the word juggernaut, owing to the aircraft's ability to take a beating in combat yet continue to excel. (Courtesy of the Historical Society of the Georgia National Guard.)

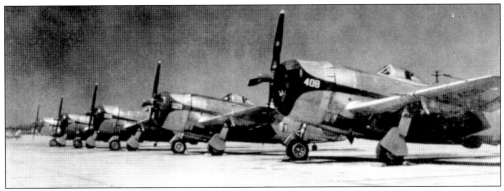

Lt. Col. Ollie O. Simpson III was the first commander of the 128th Fighter Squadron. The organization set several aviation records under his watch. In January 1949, four hundred Air National Guard aircraft assembled at Richmond, Virginia, to organize a flyover for Pres. Harry Truman's inauguration. Lieutenant Colonel Simpson and a select group of 128th Fighter Squadron pilots led the entire flyover in their P-47 Thunderbolts to honor the president. (Courtesy of the Historical Society of the Georgia National Guard.)

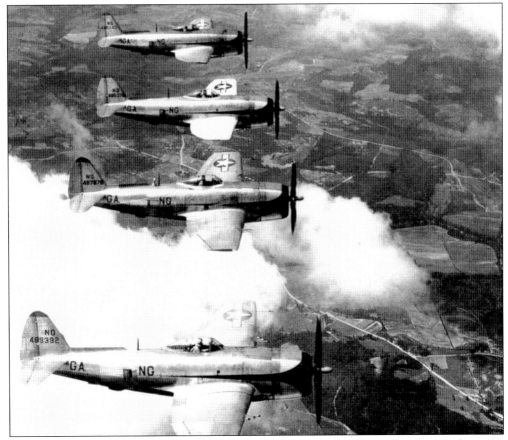

Four P-47 Thunderbolts fly in formation during a training mission. The squadron and other units of the 54th Fighter Wing attended summer camp at Chatham Field in Savannah in 1948. The squadron flew over 500 P-47 hours during the training. The 128th also flew T-6 and B-26s during the camp. (Courtesy of the Historical Society of the Georgia National Guard.)

Capt. Alfred Wickliffe flew his P-47 "Jug" for the 128th Fighter Squadron at Marietta Army Air Base. The unit was federally recognized on August 20, 1946, thus becoming the first postwar Georgia National Guard/Air Unit. Air shows were very popular in the 1940s, and the 128th Fighter Squadron pilots participated in many of them in the southeastern United States. The opportunities were great for marketing, recruiting, and general education of the public about military aviation. (Courtesy of the Historical Society of the Georgia National Guard.)

Captain Wickliffe was typical of the profile of a fighter pilot in the 1940s—dashing, brave, and dependable, consistent with heroes of the silver screen. For several months in 1948, the 128th Fighter Squadron sent pilots in their P-47s to Michigan to contribute to the production of the Warner Bros.' movie *Fighter Squadron*, starring Robert Stack and Edmund O'Brien. Late in the year, the film premiered at the Paramount Theatre in Atlanta. At the event, the 128th Fighter Squadron pilots were brought to the front of the auditorium for recognition. A loud round of applause followed from the attendees. (Courtesy of the Historical Society of the Georgia National Guard.)

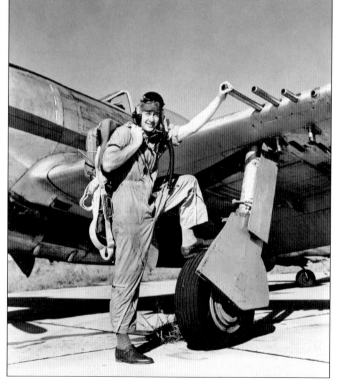

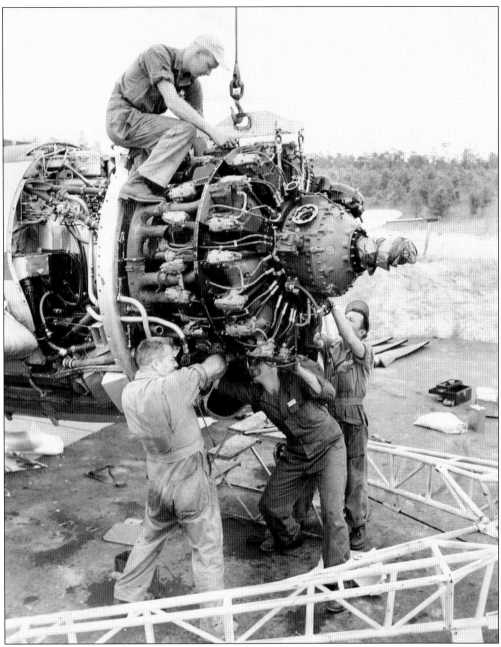

A crew performs maintenance on a P-47 engine in the summer of 1949. The work depicted here was often incorporated into the annual two-week summer training camp for units. The crew were members of the 216th Service Group. The "Service Group" concept came into being in June 1942 when all "Air Base Groups" in the Army Air Force were redesignated "Service Groups" and assigned to either the Air Service Command in the United States or to one of the Air Force Service Commands overseas. The term "Air Service Group" did not come into existence until November 1944. (Courtesy of the Historical Society of the Georgia National Guard.)

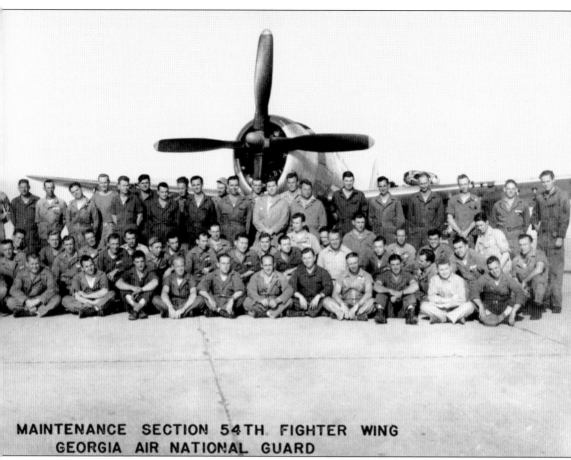

MAINTENANCE SECTION 54TH FIGHTER WING GEORGIA AIR NATIONAL GUARD

The maintenance section of the 54th Fighter Wing of the Georgia Air National Guard posed for this group photograph in April 1949. It was the largest post–World War II Air Guard wing formed in the United States. It was self-sustaining as the organization had all the necessary attached units, including medical, signal, communications, and engineering. (Courtesy of the Historical Society of the Georgia National Guard.)

Two

COASTAL GEORGIA

Chatham Field in Savannah, Georgia, was activated as a training field for heavy bombardment crews on September 18, 1943. At that time, under the direction of US Army Corps of Engineers, the pine woodland was turned into a network of runways and taxi strips for Army Air Force bomber crews who trained tirelessly and contributed greatly to victory in World War II. The unit focused on training pilots for intensive B-24 flights that brought accolades from the US War Department. On May 1, 1945, Chatham Field reverted to the jurisdiction of the Third Air Force and trained B-29 combat crews to strike the final crushing defeat on Japan. Eleven Chatham Field airmen received decorations under the previous commander, Maj. Gen. Frank O'Driscoll Hunter, of the First Air Force. A posthumous award of the Distinguished Flying Cross and the Air Medal with Three Oak Leaf clusters was given to SSgt. Joseph H. Odom of Waverly, Georgia. Odom was declared missing in action several months earlier.

"It is inevitable that Japan's fate will be that of the Luftwaffe and Germany. The payoff will be the same. We are going to use the same overwhelming airpower—a good part of which had its beginning at Chatham Field," General Hunter said. In the aftermath of World War II, Chatham Field was temporarily inactivated on January 31, 1946. Of the 324 buildings that made up Chatham Field's physical location, approximately 50 remained open.

In a speech to a local Savannah organization, the Hussars, on February 16, 1946, Marvin Griffin, the adjutant general of the Georgia National Guard, announced that the city would have a bigger role than ever before when the reorganization of the Guard was completed. The Hussars trace their lineage back as a military organization 210 years to the days of Gen. James Oglethorpe. The governor announced that 1,500 personnel slots had been allocated for National Guard air units—comprising one complete fighter wing to be shared with Atlanta. The 165th Airlift Wing began its service on October 12, 1946, at Travis Field in Savannah. Originally known as the 158th Fighter Wing, it was assigned the P-47 Thunderbolt aircraft. Later, the organization received a new jet fighter, the F-80C Shooting Star. In 1949, the wing's 158th Fighter Squadron received the Spaatz Trophy in recognition as the most outstanding Air National Guard unit in the nation.

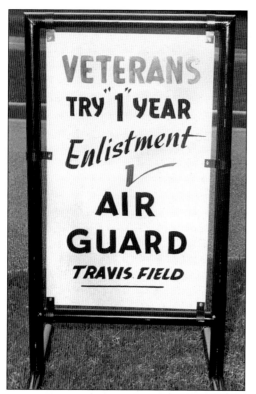

This Air National Guard recruiting sign is from the early 1950s. There was an organized effort in Savannah and other locations in the state to convince seasoned, experienced combat military veterans to give the National Guard a chance. The concept of the one-year enlistment was born as a way of enticing these veterans without the pressure of an upfront long-term commitment. (Courtesy of the Historical Society of the Georgia National Guard.)

The 165th Airlift Wing has a rich, proud history dating back to October 12, 1946, at Travis Field in Savannah, Georgia. The unit moved to Hunter Field for several years. However, it returned to Travis Field in the early 1950s prepared to meet the challenges of the future, which inevitably meant change, growth, and innovation. This undated photograph depicts the nearly finished new Headquarters building. (Courtesy of the Historical Society of the Georgia National Guard.)

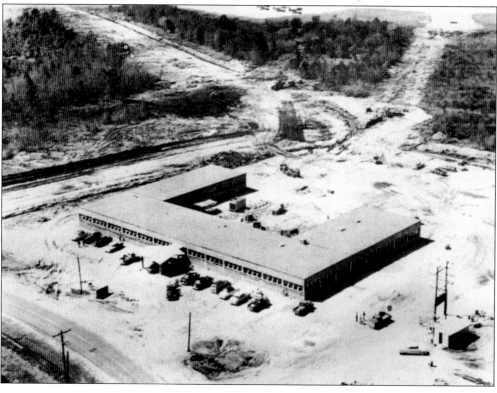

Through the years, the 165th Airlift Wing has participated in the St. Patrick's Day parade in Savannah. Participation serves as a good recruiting opportunity as well as a method to increase public awareness of the Georgia Air National Guard. In this image from the 1970s, personnel from the organization and family members stand on a platform as the parade proceeds in their direction. (Courtesy of the Historical Society of the Georgia National Guard.)

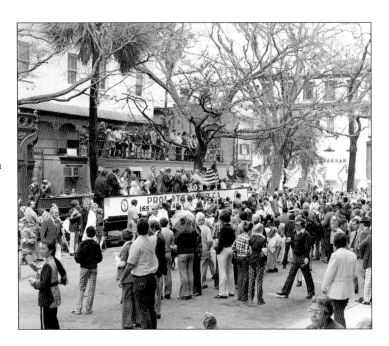

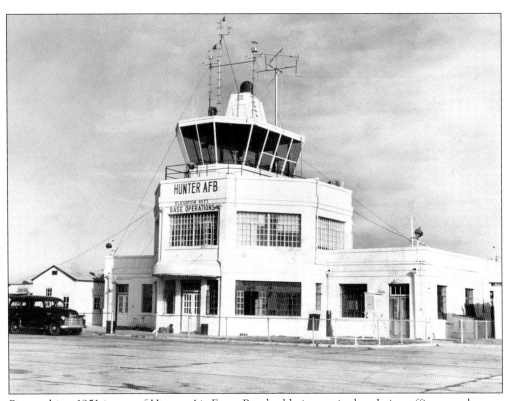

Pictured is a 1951 image of Hunter Air Force Base's old air terminal and air traffic control tower. The Air Force's Strategic Air Command's 2nd Bomb Wing was stationed at Hunter Air Force Base, as it was known at the time. (Courtesy of the Mighty Eighth Air Force Museum.)

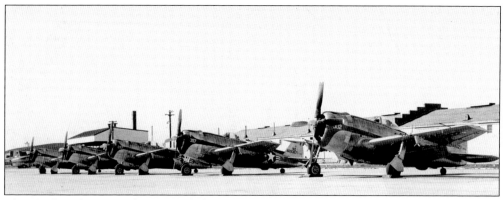

The 128th Fighter Squadron attended summer camp in 1948 at Chatham Field in Savannah, Georgia. The squadron flew over 500 P-47 hours during camp. The 128th also flew T-6 and B-26 aircraft at the same camp. Pictured are P-47s lined up on the runway at Chatham Field. (Courtesy of the Historical Society of the Georgia National Guard.)

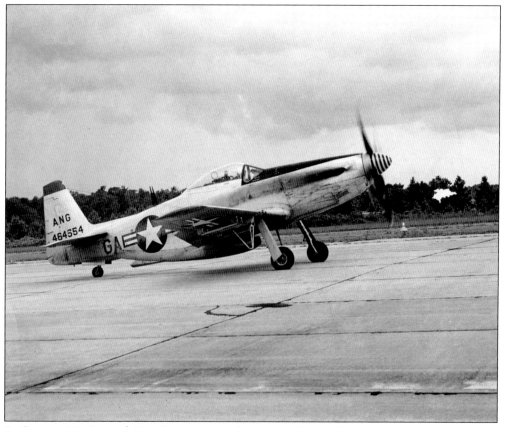

As Georgia Air National Guardsmen returned from the Korean War, they were assigned to pilot positions that required training in flying the F-51H, such as the one pictured here. Their training missions took them to Travis Field in Savannah, Dobbins Air Force Base in Marietta, and special assignments in additional locations in Georgia. (Courtesy of the Historical Society of the Georgia National Guard.)

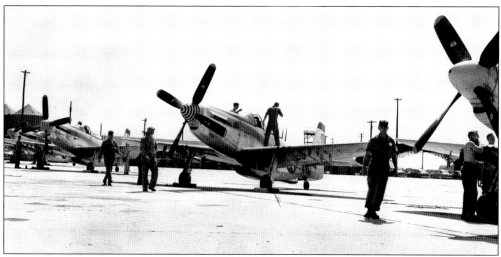

F-51H flightline operations are pictured at Travis Field summer camp in Savannah, Georgia, in the summer of 1953. The 128th Fighter Bomber Squadron was assigned five F-51H Mustangs. The unit borrowed additional Mustangs from the Texas Air National Guard to accomplish successful training. The 128th anticipated a return to jet aircraft in the future. (Courtesy of the Historical Society of the Georgia National Guard.)

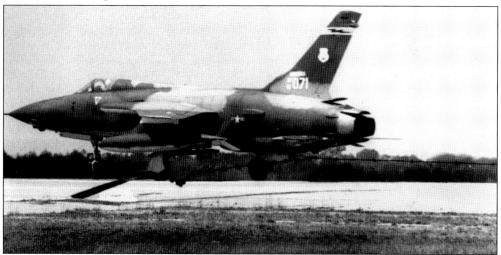

In September 1952, the Air National Guard Permanent Field Training Site was activated. Where B-24 engines once utilized facilities, generations of Air Guardsmen would train to master their combat ability. The mission was to equip and maintain the installation and provide logistical support to any unit designated by the chief, National Guard Bureau. Lt. Col. Walter M. Armstead was the first commander. In the beginning, use of the facility was limited to the summer months of June through August. Tragedy struck when Lieutenant Colonel Armstead was killed when his aircraft crashed 20 miles from the facility. Col. Albert S. Ellington Jr. served as commander for the next 21 years. During this period, the Combat Readiness Training Center (CRTC), as it came to be known, expanded to the point that it became a 365-days-a-year operation with new buildings and features. Additionally, all branches of military service, active duty, and reserve components trained at the CRTC. In this photograph from St. Patrick's Day 1975, a Virginia Air National Guard F-105 Thunderchief engages the barrier after closing its drag chute while deployed to the CRTC. (Courtesy of the Historical Society of the Georgia National Guard.)

At Travis Field in Savannah, Georgia, in June 1955, Maj. Glenn H. Herd (second from left) is congratulated by Col. William H. Kelly, base detachment commander (left) and Orrie E. Bright (third from left), chairman of the Savannah Airport Commission, after Major Herd and his crew flew the distinguished VIPs on a goodwill flight. They were accompanied by Frank Le-Hardy (third from right), airport director; Lt. Col. Homer V. Hockenberry (second from right), comptroller at Travis Field; and Maj. Louis E. Drane Jr. (right), base engineer. (Courtesy of the Historical Society of the Georgia National Guard.)

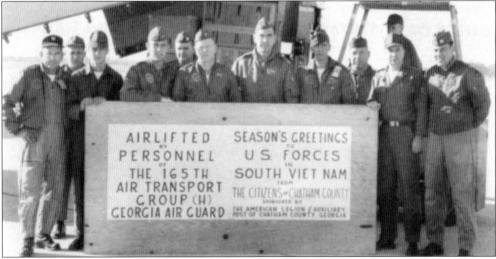

The 165th Airlift Wing and its antecedents have a long history of charitable airlift missions. This 1965 photograph shows a mission during the Christmas season for Operation Star where the payload included gifts from citizens of Chatham County, Georgia, to Air Force personnel in South Vietnam. (Courtesy of the Historical Society of the Georgia National Guard.)

This Canadian CF-18 practices for the WILLIAM TELL exercise in 1984 at the Combat Readiness Training Center in Savannah, Georgia. The Canadian team, along with the Vermont and the North Dakota Air National Guard, finished in the top three in this worldwide combat meet. (Courtesy of the Historical Society of the Georgia National Guard.)

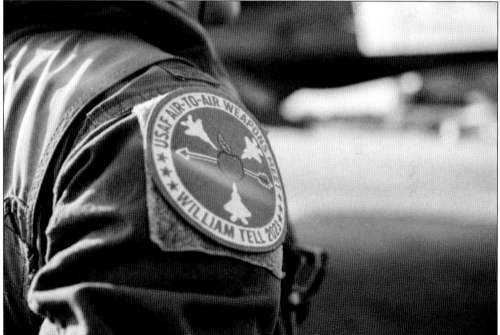

WILLIAM TELL is the air-to-air combat competition involving the finest fighter units in the Air Force. The competition challenges the ability of fighter units to accomplish air superiority and strategic defensive missions in a realistic combat environment. The competition includes pilots, weapons controller teams, aircraft maintenance specialists, and load specialists. Each participant receives a uniform patch. (Courtesy of the Georgia National Guard History Office.)

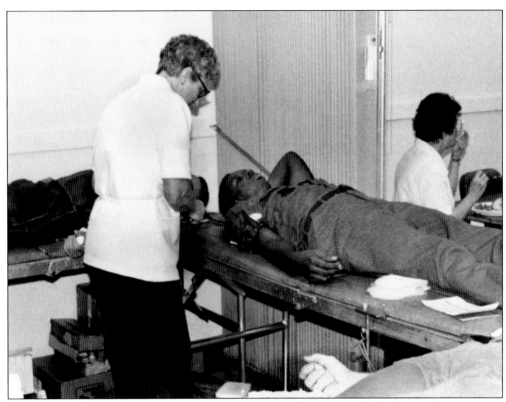

The National Guard units on the coast of Georgia have traditionally been good community neighbors, willing to support charitable programs and worthy projects in the area. In this 1970s photograph, members of the 283rd Combat Communications Squadron (located on Eisenhower Drive at the time) host a blood drive for members of the unit as well as the civilian community. (Courtesy of the Historical Society of the Georgia National Guard.)

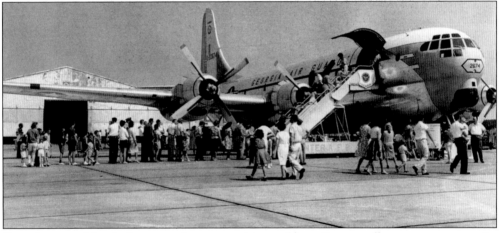

Open house and family days were always an exciting and busy time as well as a great opportunity to create goodwill, educate the public on the military, and potentially accomplish a bit of recruiting. Sadly, after 9/11, there are less events such as the one depicted here on bases. This event was an open house in the 1960s at Hunter Air Force Base in Savannah, Georgia. It was later renamed Hunter Army Air Field. (Courtesy of the Historical Society of the Georgia National Guard.)

Three

THE KOREAN CONFLICT ERA

Following World War II, the personnel strength of the Army Air Forces fell from 2.2 million to approximately 300,000. The newly created active duty Air Force had plans for a 500,000 personnel organization. In 1950, when North Korea invaded South Korea, the organization had only reached 400,000 airmen.

The first call-up of National Guard units started in October 1950 when 15 flying units and numerous support units were ordered to active duty.

When the Korean War broke out, the Air National Guard had recently begun a major organizational change in order to create conformity with the new combat wing parameters of the regular Air Force. In the summer of 1950, several squadrons converted to jet aircraft, including the 158th Fighter Squadron based in Savannah. On October 10, 1950, the squadron was called to active duty. During training in California, the 158th converted to the new F-84 Thunderjets.

One week later, the wing departed Alameda, California. Most of the aircraft were transported on board the USS *Sitkoh Bay*. The aircraft were protected by coats of Cosmoline and secured to the carrier decks. The first group arrived in Yokosuka, Japan, on July 27, 1951. The wing's mission was the air defense of northern Japan in case of an attack on those islands.

In December 1951, personnel and planes were ferried to Korea to participate in missions against the communists in North Korea. Many of their missions involved the support of ground forces with frontline bombing and strafing of enemy positions. They also became the first jet-equipped units to experiment with in-air refueling from KB-29 tankers. Other Georgia Air Guard units involved included the 116th, 117th, and 129th Air Control and Warning Squadrons.

In May 1952, the 128th Fighter Squadron deployed to Chaumont, France, to support the war effort. In July 1952, most of the personnel of the Georgia Air National Guard returned to state control.

Eighty percent of the Air National Guard was called into federal service. Those flying units not deployed to Korea were either dispatched to build up NATO in Europe or assigned to major air commands in the United States to strengthen the Air Force for a possible global military confrontation with the Soviet Union. During the Korean War period, mobilized Air Guard units operated a wide variety of aircraft, including F-47s, F-51s, B-26s, B-29s, RB-29s, RB-36s, B-45s, F-80s, F-84s, and F-86s.

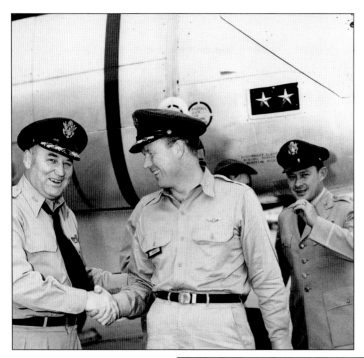

Gen. George G. Finch (left) and Col. Bernard M. Davey (center) greet each other on the runway as Maj. Jack Dobbins (right) looks on. Finch was an outspoken critic of efforts to federalize the Air National Guard after World War II. He strongly believed that the air assets of the Guard should remain under state control during peacetime. His leadership earned Finch the respect of personnel under his command as well as many civilians that he encountered during his tenure in the organization. (Courtesy of the Historical Society of the Georgia National Guard.)

MSgt. Obie Brock, pictured in maintenance mode, was a longtime crew chief for General Finch. The ANG A-26 was the favorite form of transportation for the general. Finch gained the respect of all Georgia Air National Guardsmen, officer and enlisted, due to his strong belief in the value of the Air Guard's capabilities. His habit of leaving the office environment and visiting the airmen in the field was appreciated as well. (Courtesy of the Historical Society of the Georgia National Guard.)

Col. James L. Riley (standing) replaced General Finch as commanding general of the 54th Fighter Wing when Finch was appointed chief of the Air Force Division of the National Guard Bureau. Later, Riley was promoted to brigadier general. (Courtesy of the Historical Society of the Georgia National Guard.)

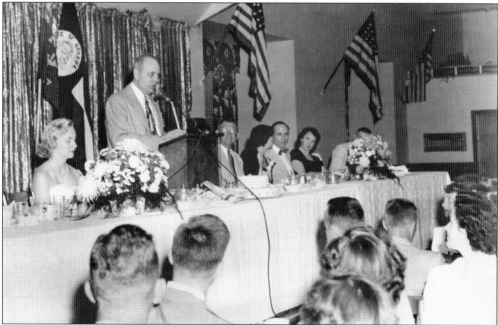

Brig. Gen. James L. Riley speaks to a civic organization in the early 1950s. He was a successful attorney and active in the community with several charitable organizations. Late in his military career, General Riley assumed command of the Fourth Air Force Reserve Region, with Headquarters at Randolph Air Force Base, Texas. This region, one of six within the Continental Air Command, was responsible for the supervision of all Air Force Reserve training in Texas, Arkansas, Louisiana, Oklahoma, and New Mexico. Among the Reserve units controlled by the region were two troop carrier wings, 12 Air Force Reserve recovery groups, and two hospitals. (Courtesy of the Historical Society of the Georgia National Guard.)

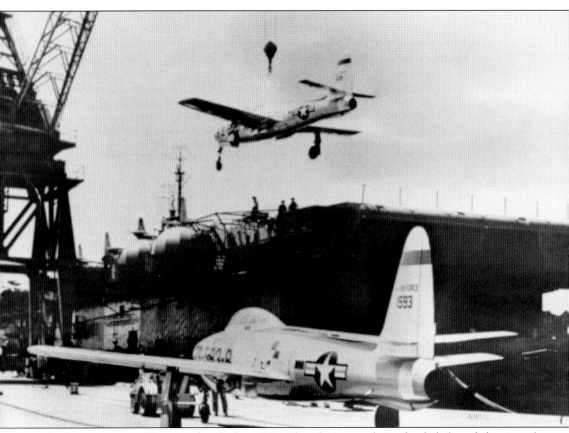

As the situation in Korea escalated, these F-84 Thunderjets are being loaded aboard the aircraft carrier *Sitkoh Bay* prior to leaving the United States with equipment and personnel of the 116th Fighter Bomber Wing. The carrier arrived at Yokosuka, Japan, on July 27, 1951. (Courtesy of the Historical Society of the Georgia National Guard.)

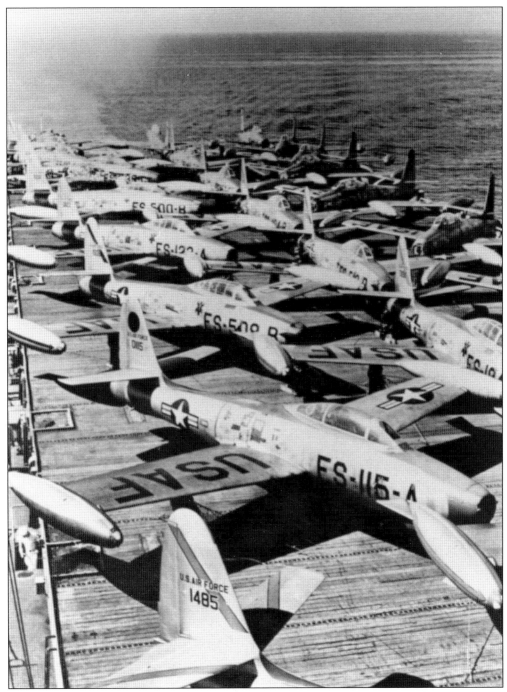

The 116th Fighter Bomber Wing departed from Alameda, California. Most of the aircraft were transported onboard the aircraft carrier *Sitkoh Bay*. The remainder followed two days later on the aircraft carrier *Windham Bay*. The aircraft were protected by coats of Cosmoline and secured to the carrier decks. The wing was assigned to the Japan Air Defense Force. Its mission was the air defense of northern Japan in case of an attack on those islands. (Courtesy of the Historical Society of the Georgia National Guard.)

Brig. Gen. Ben L. Patterson Jr. (right), commander of the 116 Tactical Fighter Wing and later assistant adjutant general/air, takes the reins of a plane at Dobbins Air Force Base. He served in Korea in 1951–1952 with the 158th Fighter Squadron, flying 101 combat missions in F-51s and earned the Distinguished Flying Cross medal. Briefly, he practiced law but rejoined the 158th Fighter Squadron in Savannah, Georgia. During that period, he flew the F-84D, F-86L, C-97, and C-124C aircraft. He served at the 116th for 10 years, flying the F-100D, F105G, F-4D and F-15A aircraft. (Courtesy of the Historical Society of the Georgia National Guard.)

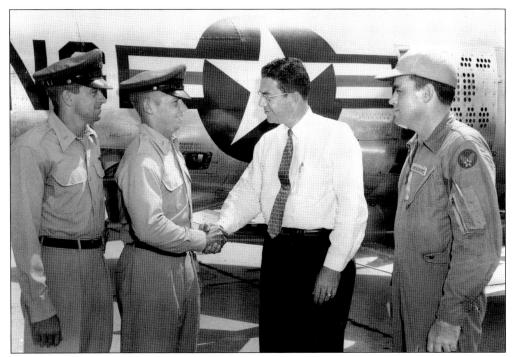

Gov. Ernest Vandiver (third from left) greets personnel at the 116th. He served as a bomber pilot in the Army Air Force in World War II. Later, he was appointed the adjutant general for Georgia. He was the youngest person to hold such position in the United States. He held the position from November 1948 to June 1954. He served as adjutant general again for 10 months in 1971. (Courtesy of the Historical Society of the Georgia National Guard.)

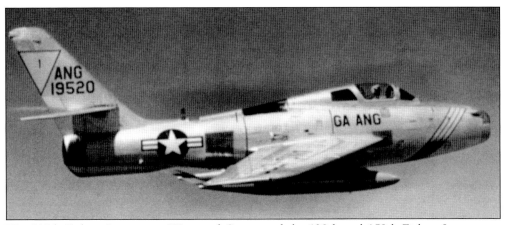

The 116th Fighter Interceptor Wing and Group and the 128th and 158th Fighter Interceptor Squadrons were redesignated as "Fighter Bomber" on December 1, 1952, and assigned F-84D aircraft (pictured above). The wing included two squadrons outside the state of Georgia. They were the 159th at Jacksonville, Florida, and 157th at Columbia, South Carolina. (Courtesy of the Historical Society of the Georgia National Guard.)

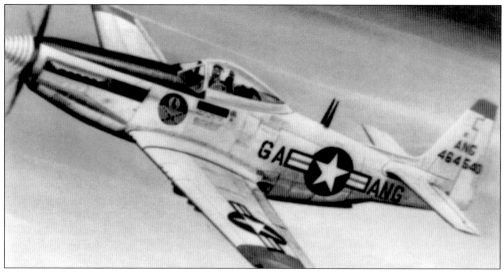

In March 1953, the Air National Guard's (ANG) 138th Fighter Interceptor Squadron at Syracuse, New York, and its 194th Fighter Bomber Squadron at Hayward, California, maintained two F-51D fighters, each on five-minute air defense runway alert from one hour before sunrise to one hour after sunset. The experiment was the idea of Maj. Gen. George Finch that he developed as chief of the Air Division, National Guard Bureau. The intent was to aid the overworked Air Defense Command (ADC) in defending the continental United States against the threat of Soviet air attacks. The program provided badly needed additional training opportunities for ANG fighter pilots in F-51D fighters (pictured). (Courtesy of the Historical Society of the Georgia National Guard.)

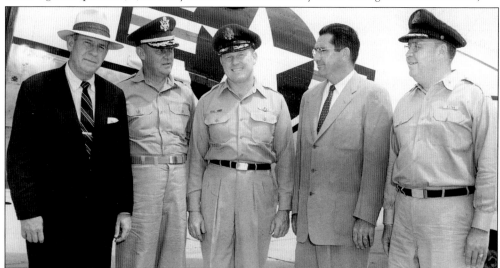

Maj. Gen. George J. Hearn, the adjutant general, grounded 60 F-84D Thunderjets on January 19, 1957, after being shown evidence that they were not airworthy. The jets had been temporarily grounded pending the outcome of an investigation into the crash of an F-84D piloted by Capt. Edward A. Woodard. Upon receiving a report from General Hearn, Gov. Marvin Griffin said, "I will not jeopardize the lives of our pilots, and the planes will remain grounded until such time as they are replaced or can be placed in a safe condition." Pictured are, from left to right, Gov. Marvin Griffin, Gen. George Hearn, Col. Bernard M. Davey, unidentified, and Brig. Gen. Homer Flynn, assistant adjutant general/air. (Courtesy of the Historical Society of the Georgia National Guard.)

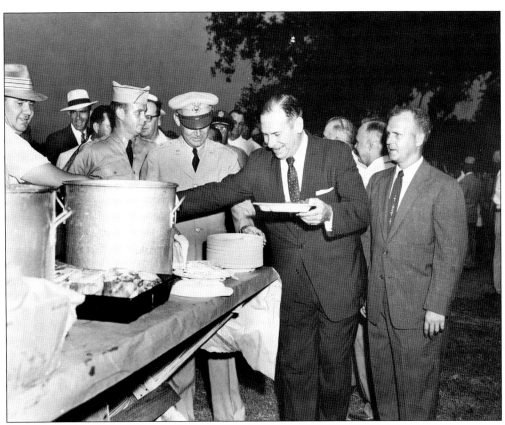

Gov. Marvin Griffin enjoyed getting out in the field with the enlisted members of the Georgia National Guard. He is pictured here in self-serve mode for a barbeque lunch. During World War II, Griffin enlisted in the Army, and he commanded a unit in the South Pacific. He eventually attained the rank of lieutenant colonel. In 1944, Gov. Ellis Arnall appointed him adjutant general of the Georgia National Guard, a post he held until 1947. (Courtesy of the Historical Society of the Georgia National Guard.)

Colonel Grizzard (left) and General Davey (right) discuss the F-84F aircraft with Col. Phil Colman (center), who served as commander of the 158th Fighter Bomber Squadron from December 1955 to July 1958. Colman was a "Double Ace" due to his feat of shooting down six Japanese Zero fighters in China during World War II and later downing four MIG-15s over North Korea. (Courtesy of the Historical Society of the Georgia National Guard.)

Pictured is a 1950s visit to the 116th by National Guard Bureau staff, including Lt. Col. I.G. Brown (second from right). Later, Brown became the first officer assigned as director of the Air National Guard. He developed the idea that the enlisted corps in the Air Guard should have an academy to increase their professionalism. After significant planning, the Air National Guard NCO Academy was founded. Brown hired Maj. Edmund C. Morrisey of the Texas Air National Guard to design the program in detail. (Courtesy of the Historical Society of the Georgia National Guard.)

In 1968, the first classes of the NCO Academy were held in an aircraft hangar. Today's campus is called the I.G. Brown Training and Education Center. It trains 4,200 Guard, Reserve, regular Air Force, and international students per year. The students attend professional military education and continuing education classes at the center, which is located at McGhee Tyson Air National Guard Base in Knoxville, Tennessee. (Courtesy of the Historical Society of the Georgia National Guard.)

Four

IMPORTANT AIRCRAFT

In 1973, the 165th Tactical Airlift Group acquired C-130E Hercules aircraft to replace the aging C-124. Many of the original C-130 aircraft delivered to the group had flown in the Vietnam War. Using its aft-loading ramp and door, the C-130 can accommodate a variety of oversized cargo, including everything from utility helicopters and six-wheeled armored vehicles to standard cargo and military personnel. In an aerial delivery role, it can airdrop loads up to 42,000 pounds.

The 116th Tactical Fighter Wing converted to the F-15 Eagle in 1987. The F-15 Eagle is an all-weather, extremely maneuverable, tactical fighter designed to permit the Air Force to gain and maintain air supremacy over the battlefield through a mixture of maneuverability and acceleration, range, weapons, and avionics. With the most sophisticated, tactical fighter in the Air Force, the unit's mission changed to offensive and defensive counter-air operations.

In May 1993, the US Air Force announced that the 116th Tactical Fighter Wing would transition to the 116th Bomb Wing and move from Dobbins Air Reserve Base to Robins Air Force Base. The F-15 fighter aircraft would be replaced by the B-1B bomber. It featured the highest speed and greatest payload of any bomber in the Air Force industry at the time. The B-1B Lancer set speed records in categories of speed/payload/distance, time to climb, and around the world. It was able to fly low and with great speed to targets anywhere.

Team JSTARS (Joint Surveillance Target Attack Radar System) was the first organization in the US Air Force to activate under the Total Force Initiative as a "blended" wing. America's first Total Force wing—the former 93rd Air Control Wing, an active-duty Air Combat Command unit, and the 116th Bomb Wing, a Georgia Air National Guard unit—was deactivated October 1, 2002. The 116th Air Control Wing was activated, blending Guard and active-duty airmen into a single unit. In October 2011, the active/associate construct was formed by the newly activated 461st Air Control Wing as a member of Team JSTARS. The E-8C Joint Surveillance Target Attack Radar System, or Joint STARS, is an airborne battle management, command and control, intelligence, surveillance, and reconnaissance platform aircraft. Its primary mission is to provide theater ground and air commanders with ground surveillance over land and water to support attack operations and targeting that contributes to the delay, disruption, and destruction of enemy forces.

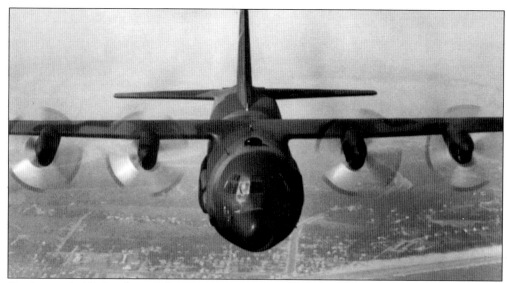

On August 8, 1975, a fleet of the C-130E Hercules aircraft came to the international airport in Savannah to replace the older C-124s of the 165th Tactical Airlift Group. On April 15, 1992, the unit was redesignated the 165th Airlift Group. On October 1, 1995, the unit was redesignated to its current name, the 165th Airlift Wing. (Courtesy of the Historical Society of the Georgia National Guard.)

Col. Steve Westgate (seated) assumed command of the 165th Airlift Wing in December 1999. He was only the second commander in the history of the unit to hold both the wing commander position as well as the full-time position of air technician commander. He followed the command of Col. Wick Searcy (at podium), who became the director of operations for Headquarters, Georgia Air National Guard. Earlier that year, a longtime mission—VOLANT OAK—came to an end at Howard Air Force Base in Panama as the final development in the Panama Canal hand over objective. (Courtesy of the Historical Society of the Georgia National Guard.)

The C-130 can transport large military assets over great distances. Utility helicopters, such as the one pictured here, are frequently transported to many locations around the globe. (Courtesy of the Historical Society of the Georgia National Guard.)

In 1988, three aircraft and 28 personnel of the 116th Tactical Fighter Wing deployed to Hickam Air Force Base in Hawaii for SENTRY ALOHA, a Total Force exercise. The exercise was the first time that aircraft from the 116th were placed on alert status since 1960. The 116th aircraft were positioned to augment the alert status of the Hawaii Air National Guard during its transition to the F-15 aircraft. (Courtesy of the Historical Society of the Georgia National Guard.)

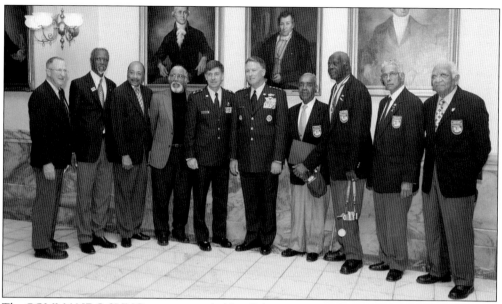

The COMMANDO SLING exercise was held in February 1995. The 116th Tactical Fighter Wing deployed six F-15 Eagles to Singapore. The exercise supported US joint defense agreements in Southeast Asia. The United States and Singapore shared a history of military cooperation through joint training and exercises involving both naval and air forces. Lt. Col. Scott A. Hammond served as detachment commander phase I. Lt. Col. Richard A. Zatorski served as detachment commander phase II. Pictured is a later image of Major General Hammond as the assistant adjutant general/air (fifth from left) at the Heritage to Horizons celebration to commemorate the 60th anniversary of the establishment of the US Air Force. The celebration took place at the Georgia State Capitol on February 12, 2007. He is joined by several veteran members of the Atlanta Chapter, Tuskegee Airmen. (Courtesy of the Georgia National Guard History Office.)

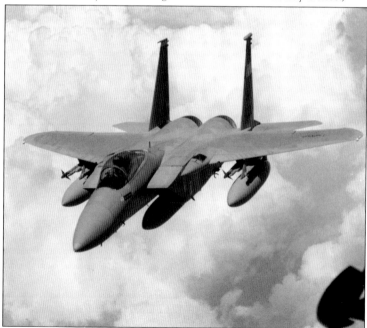

F-15C, D, and E models were deployed to the Persian Gulf in 1991 in support of Operation DESERT STORM. They proved their superior combat capability. F-15C fighters accounted for 34 of the 37 Air Force air-to-air victories. F-15Es were operated mostly at night, hunting Scud missile launchers and artillery sites using the LANTIRN system. (Courtesy of the Historical Society of the Georgia National Guard.)

The nose art designates the occasion. On August 30, 1995, four F-15 Eagles of the 116th Fighter Wing took a final ceremonial flight. "It's tough, particularly for people who have been fighter pilots all their lives," Col. Bruce MacLane, commander of the 116th, said. Colonel MacLane led the flight, along with Lt. Col. Bob Doehling, Lt. Col. Rich Zatorski, and Maj. Tom Jordan. MacLane joined the wing in 1973. He was one of only two pilots to have flown the F-100 Super Sabre, F-4 Phantom, F-105 "Wild Weasel," and the F-15. During that time, the unit won an unprecedented nine Air Force Outstanding Unit awards. (Courtesy of the Historical Society of the Georgia National Guard.)

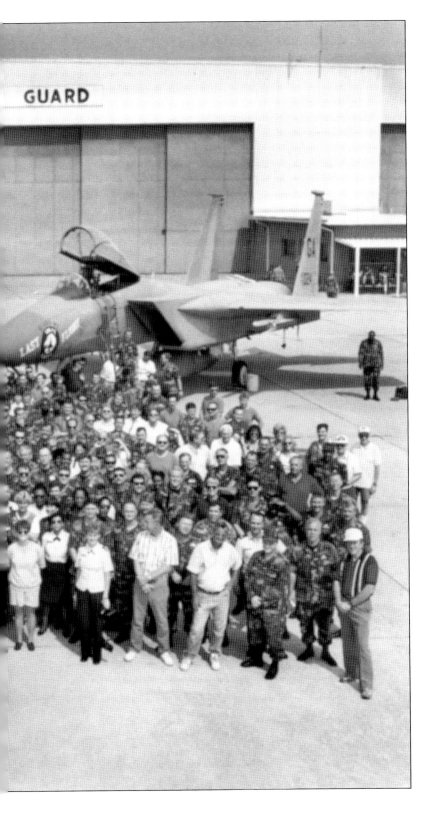

Colonel MacLane was promoted to brigadier general in 1996 and became commander of the 116th Bomb Wing. The unit converted to the B1-B bomber aircraft. He guided the unit in its conversion and relocation to Warner Robins Air Force Base. In June 1998, Col. George T. Lynn assumed command of the wing and led the organization to success as it received notice it had been awarded its 10th Air Force Outstanding Unit award. (Courtesy of the Historical Society of the Georgia National Guard.)

For nearly 50 years, Dobbins Air Reserve Base in Marietta, Georgia, was the home of the 116th Fighter Wing. In 1996, the unit moved 125 miles south to Robins Air Force Base in Warner Robins, Georgia. Pictured here is an aerial view of the base in the 1960s. On April 1, 1996, it was officially designated as the 116th Bomb Wing, thus becoming the second Air National Guard unit in the country to receive the B-1B. The 116th Civil Engineering Squadron was tasked with the gigantic assignment of managing a multimillion dollar building program for the B-1 force beddown at the new location. (Courtesy of the Historical Society of the Georgia National Guard.)

In the summer of 1988, former Flying Tiger Brig. Gen. Robert L. Scott Jr. (Ret.) received a gift for his 80th birthday. An F-15 Eagle was stenciled with his name and was readied for flight at Dobbins Air Force Base. Scott got his wish—a flight in the F-15. Maj. Dudley Durrant was Scott's check pilot during the flight. After the flight, Brigadier General Scott could be heard shouting, "This— Eagle! It's the greatest fighter in the world!" Scott (right) talks to Lt. Col. Don V. Hubbard (left) in advance of the flight. (Courtesy of the Historical Society of the Georgia National Guard.)

Brig. Gen. Robert L. Scott Jr. (Ret.) is well known as one of the famed Flying Tigers of World War II. Scott became commander of the newly formed 23rd Fighter Group in Gen. Claire Chennault's China Air Task Force. He was author of the book *God Is My Co-Pilot*, which Warner Bros. turned into a feature film. The military ordered Scott to Hollywood to serve as technical advisor for the film. The movie premiered in Macon, Georgia, in February 1945. In his later years, Scott served as a pivotal fundraiser and volunteer for the Museum of Aviation at Warner Robins Air Force Base. The museum has featured a longtime exhibit in honor of his life. Scott passed away in 2006 at the age of 97. Pictured are, from left to right, Lt. Col. Don Hubbard, Brig. Gen. Robert Scott (Ret.), Col. Steve Kearney, and unidentified. (Courtesy of the Historical Society of the Georgia National Guard.)

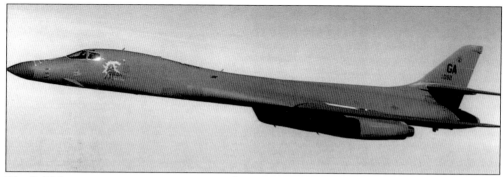

The B-1B Lancer is a strategic penetrator that can perform as a cruise missile carrier or as a conventional weapons carrier for theater operations. The bomber can also serve in a variety of collateral missions such as long-range sea surveillance and mine-laying operations. (Courtesy of the Historical Society of the Georgia National Guard.)

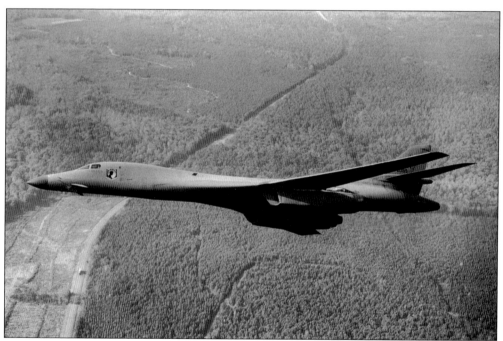

The swing-wing design and turbofan engines of the B1-B Lancer not only provide greater range and high speed at low levels but also greatly enhance the bomber's survivability. The wings can be placed at the full forward position to allow a much shorter takeoff role and faster escape from a main operating base or dispersal airfield under threat of attack. Once in flight, it can be swept back for high-altitude cruise or low-level high-subsonic penetration. (Courtesy of the Historical Society of the Georgia National Guard.)

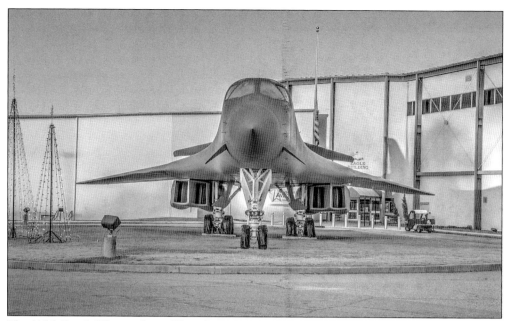

The 116th Bomb Wing and its affiliated 128th Bomb Squadron were declared "Initial Operational Capability" and "Combat Mission Ready," respectively, in the B-1B in 1997 after the move to Warner Robins Air Force Base, which included the updating of facilities and the hiring of new pilots and weapons systems operators. (Author's collection.)

Joint STARS evolved from Army and Air Force programs to develop, detect, locate, and attack enemy armor at ranges beyond the forward area of troops. The first two developmental aircraft deployed in 1991 to Operation DESERT STORM and also supported Operation JOINT ENDEAVOR in December 1995. Pictured is a Joint STARS aircraft at Robins Air Force Base in 2023. (Courtesy of the Historical Society of the Georgia National Guard.)

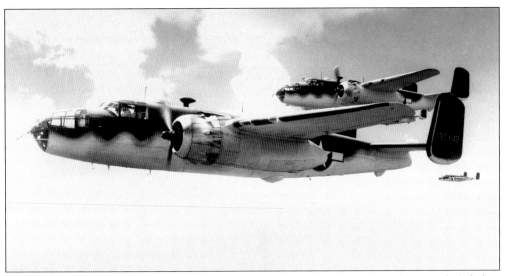

On June 25, 1943, tragedy stuck when a B-25 similar to the aircraft in the photograph failed to reach its destination on a mission in Tampa, Florida. Crew members of the 128th Observation Squadron included Capt. John R. Turner, who was the pilot; TSgt. J.B. Grogan; TSgt. Thomas L. Johnson; and SSgt. Edward W. Simpson. The other crew members were First Officer Milburn W. Rockett, copilot; SSgt. Jesse R. Ferris, California; Sgt. Clarence Lankford, North Carolina; and Sgt. Floyd Gilcrease, Arizona. Even after an extensive search that included Army and Navy personnel, the aircraft and crew members were never found. It is believed that they crashed into the Gulf of Mexico. (Courtesy of the Historical Society of the Georgia National Guard.)

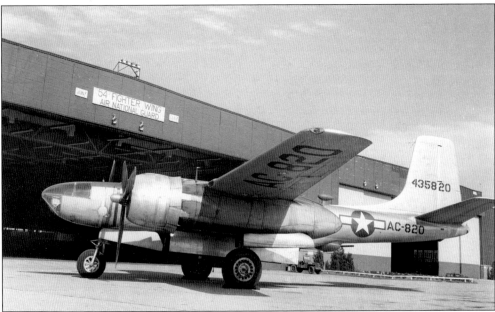

When Maj. Gen. George Finch left the Georgia Air National Guard, he became commander of 14th Air Force. He took command in January 1955, thus becoming the first Air National Guard officer to command a major Air Force. During his tenure, Finch's favorite mode of transportation was the B-26, similar to this aircraft at the 54th Fighter Wing. (Courtesy of the Historical Society of the Georgia National Guard.)

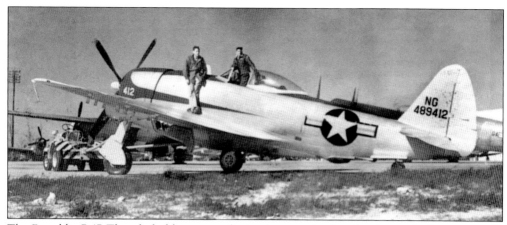

The Republic P-47 Thunderbolt's greatest distinction was the fact that it was the heaviest single-engine fighter to see service in World War II. Parked alongside any of its wartime contemporaries, the Thunderbolt dwarfs them with its size. Despite its size, the P-47 proved to be one of the best-performing fighters to see combat. It was produced in greater numbers than any other US-produced fighter. (Courtesy of the Historical Society of the Georgia National Guard.)

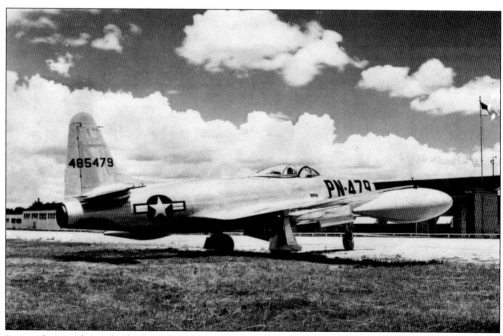

It was designed as a high-altitude interceptor, but the F-80C Shooting Star was used greatly as a fighter-bomber in the Korean Conflict, primarily for low-level rocket, bomb, and napalm attacks against ground targets. The 158th Fighter Squadron of the Georgia Air National Guard became one of the first units in the country equipped with this jet aircraft. (Courtesy of the Historical Society of the Georgia National Guard.)

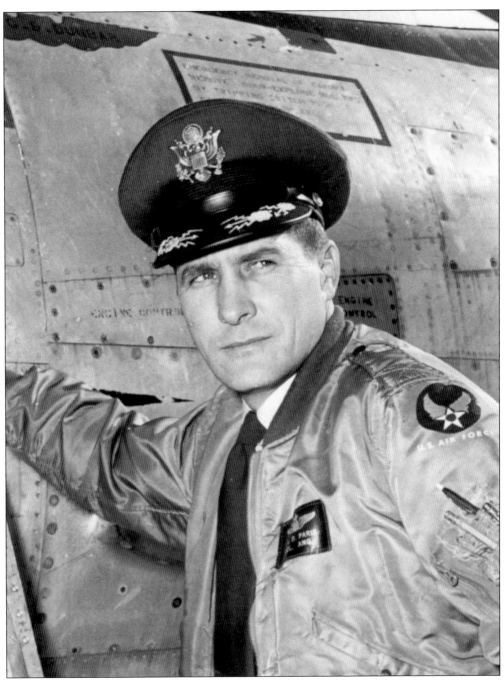

Maj. Gen. Joel B. Paris III was the adjutant general of the Georgia National Guard from November 1971 to January 1975. He became an ace in the Pacific during World War II. Paris downed nine Japanese aircraft while flying P-40s and P-38s in the South Pacific. He flew 167 combat missions. He was the first pilot to take F-84Fs into the skies at Dobbins Air Force Base on March 11, 1957. He retired in 1970. His last assignment was as special advisor for National Guard Affairs to the deputy chief of staff for Air Force Operations at the Pentagon. (Courtesy of the Historical Society of the Georgia National Guard.)

Five

THE 1960S AND 1970S

The specter of the Cold War hung over all military activities of the 1960s. The distrust between the United States and the Soviet Union reached a crescendo in the fall of 1962 when Air Force surveillance planes discovered that the Soviets were secretly constructing 40 launch pads for medium-range nuclear missiles in Cuba. The Cuban Missile Crisis was a focal point for personnel of all Air Force components—active duty, National Guard, and Reserve—who understood the importance of their jobs in defense of the United States and its allies.

The 116th Air Defense Wing converted to the 116th Air Transport Wing in April 1961, thereby taking on the responsibility of flying C-97 transport aircraft. The conversion marked a major change in wing history. A flight simulator was installed at Dobbins. Electronically simulating the flying characteristics of the C-97 allowed pilots and flight engineers to train for all emergencies and related contingencies. During the height of the Cuba crisis, four Georgia Air National Guard C-97s took off on a unique support mission to Thule, Greenland. They were called upon by the Military Air Transport Service (MATS) to fill in for regular MATS cargo trips to the Arctic outpost.

Georgia Air National Guard crews from both groups and squadrons flew numerous missions to Vietnam. In January 1966, all "Air Transport" units were redesignated as "Military Airlift" units. The 116th flew on average six flights per month during the most active period of the Vietnam War. Many flights airlifted wounded personnel from the war zone. One such flight began in Savannah as a routine mission in June 1966. After touching down at Da Nang, Tactical Airlift Command requested the crew to evacuate wounded personnel to Clark Air Force Base in the Philippines. The aircraft was loaded and departed minutes before enemy troops descended on the area.

The decision was made to retire C-124 aircraft in 1974. Senior Air Force officials proposed that the 165th Tactical Airlift Group convert from eight C-124s to 24 O-2 Cessna Skymasters. Local Chatham officials believed the change would have a negative impact on the community. Elected officials leveraged a change in plans. The group converted to a tactical airlift mission and were assigned the C-130 Hercules aircraft.

The 283rd Combat Communications Squadron was activated on April 1, 1976, at the Rhodes Air National Guard Station on Eisenhower Drive in Savannah, Georgia.

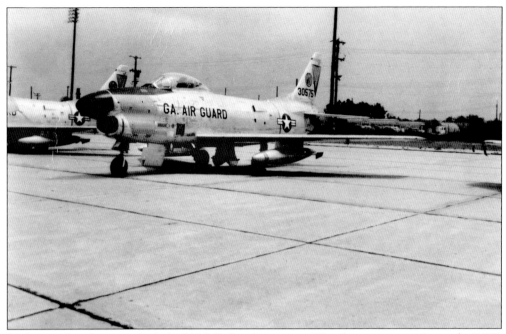

As the new decade approached, the 116th Fighter Interceptor Wing began a conversion to the F-86L Sabre jet. To qualify in the jet, pilots were sent to ground school and attended a mobile training unit, which consisted of operational mock-ups of the aircraft's systems. The F-86L flight simulator cost $1 million, and it was housed in a building with forced draft air-conditioning. (Courtesy of the Historical Society of the Georgia National Guard.)

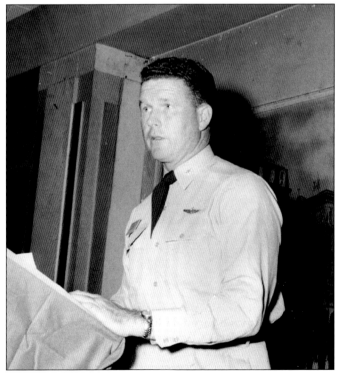

The F-86L aircraft continued to prove its mettle in major training exercises. Maj. Gen. Bernard "Bud" M. Davey, pictured here, was the commander of the 116th Fighter Interceptor Wing. He was a longtime member of the Georgia Air National Guard and a recent graduate of the Air War College. He presided over an operational readiness test conducted January 16–17, 1960. The exercise simulated a foreign government's invasion of coastal Georgia. F-86Ls were scrambled several times. Over 1,000 airmen from Dobbins Air Force Base participated in the exercise. (Courtesy of the Historical Society of the Georgia National Guard.)

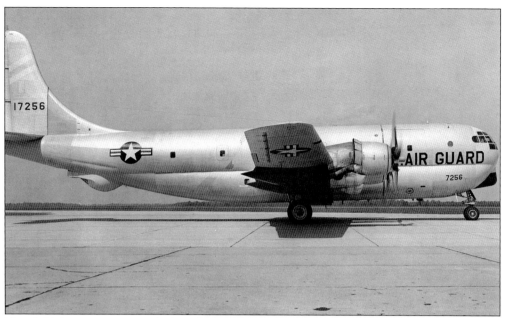

This C-97 Stratocruiser is parked on the runway at Dobbins Air Force Base in August 1961 as the newly renamed 116th Air Transport Wing begins annual field training at the home station. Crew members were given comprehensive training in the complex systems of the aircraft. The former jet fighter pilots on staff were quick to adapt, and soon, most of them were prepared to make flights to the Caribbean, Puerto Rico, and Panama. (Courtesy of the Historical Society of the Georgia National Guard.)

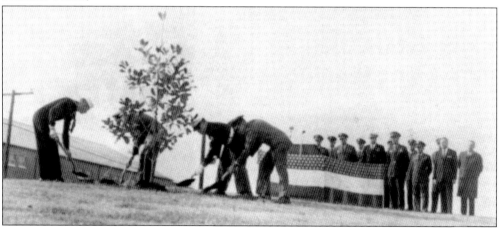

On December 7, 1963, airmen of the Georgia Air National Guard's 116th Air Transport Wing stood in formation with members of the US Navy, US Marine Corps, and others to witness a tree-planting ceremony in memory of Pres. John F. Kennedy in the aftermath of his tragic assassination. Brig. Gen. George H. Wilson, commander of Dobbins Air Force Base, opened the ceremony by calling the formation to attention. Chaplain (Maj.) Robert Pooley Jr. of the Georgia Air National Guard's 116th Air Transport Wing, gave the opening prayer. CMSgt. Emmett N. Donald of the 116th Air Transport Wing represented the Georgia Air National Guard during the tree-planting ceremony. Chaplain (Lt. Cdr.) Robert E. Osman of Naval Air Station Atlanta offered the dedicatory prayer, after which the Georgia Air National Guard's 530th Air Force Band, led by 1st Lt. Russell Moore, played the national anthem. (Courtesy of the Historical Society of the Georgia National Guard.)

In June 1948, the US Department of Defense consolidated the Air Transport Command and the Naval Air Transport Service to create the Military Air Transport Service (MATS), which became the department's single manager for airlift service. Continued expansion of the airlift mission necessitated another redesignation, and in January 1966, the Military Air Transport Service became the Military Airlift Command. This sign was posted at Naval Air Station Atlanta, colocated with Dobbins Air Force Base, until 1966. (Courtesy of the Historical Society of the Georgia National Guard.)

Dobbins and the Lockheed Marietta facility have had a long, cooperative relationship. In this photograph from the 1960s, Col. Robert E. Buechler (left), assistant for Air Guard Affairs, Headquarters, MATS, and Brig. Gen. John R. Dolny (right), commander of the 133rd Air Transport Wing, Minnesota Air National Guard, receive a briefing from Col. Charles Thompson (center), deputy commander of the 116th Air Transport Wing. He explained C-97 engine buildup facilities at Dobbins Air Force Base. The visitors were members of the MATS Reserve Forces Policy Council. The itinerary also included a visit to the Lockheed plant, which was in the process of work and development on the C-121 aircraft. (Courtesy of the Historical Society of the Georgia National Guard.)

On July 22, 1968, Brig. Gen. Charles Thompson, commander of the 116th Military Airlift Wing, presented the posthumous appointment of captain in the regular US Air Force to Erwin H. Cowart of Tucker, Georgia. Cowart, a Reserve pilot on active duty, was killed when his B-52 aircraft was lost on a test Strategic Air Command flight from Ramey Air Force Base, Puerto Rico. His wife, Kathleen M. Cowart, and son John received the special orders from Thompson. Several Georgia Air National Guardsmen participated in the ceremony at Dobbins Air Force Base. The active duty Air Force selected the 116th to conduct the ceremony, a good example of the fact that all the Air Force components—active, Guard, Reserve, and Civil Air Patrol—are a family of shared values. (Courtesy of the Historical Society of the Georgia National Guard.)

Gov. Carl Sanders addresses the 116th Air Transport Group at Dobbins Air Force Base. Sanders served in the military as well. He was a pilot in the US Army Air Corps during World War II. He was governor of Georgia from 1963 to 1967. He passed away on November 16, 2014. (Courtesy of the Georgia National Guard History Office.)

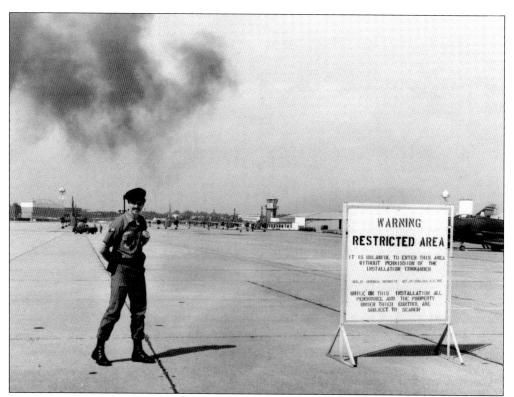

After the Vietnam War, the US Air Force determined that there was a need to strengthen the role of the Air Police. In 1966, the name of the career field was changed to "Security Police." The name was considered more concise, descriptive, and broadly applicable to the many tasks and responsibilities these airmen were ordered to carry out. Pictured here is a Security Police enlisted airman in the Georgia Air National Guard working the flightline. (Courtesy of the Historical Society of the Georgia National Guard.)

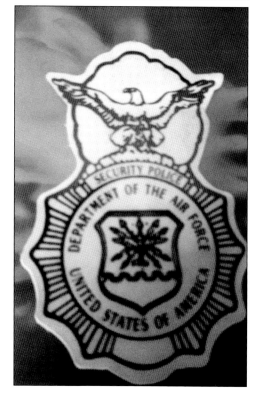

The Security Police shield is a symbol of authority and responsibility to each member who wears it. Each shield was issued to on duty Security Police at weapons issue and subsequently turned in after each shift. This policy was relaxed in the mid-1960s. The badge remained squadron property, but it was retained by the individual until Permanent Change of Station (PCS). (Courtesy of the Historical Society of the Georgia National Guard.)

Georgia Air National Guard Security Police are pictured training at Fort Stewart, Georgia, on crowd-control procedures in the mid-1960s. In March 1971, the enlisted career field was divided into two separate fields—security specialist and law enforcement specialist. (Courtesy of the Historical Society of the Georgia National Guard.)

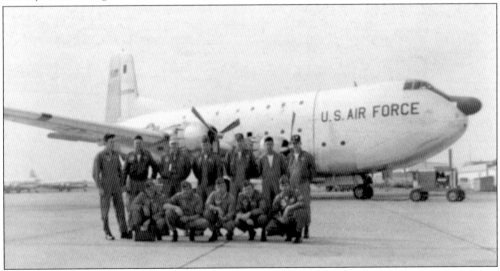

The Georgia Air National Guard's 116th Military Airlift Group became the first Air Guard unit in the nation to receive the C-124 Douglas Globemaster in December 1966. The 116th Military Airlift Group was one of three Air Guard groups in the United States to phase out the Boeing C-97 Stratocruisers for the C-124 as it could carry more than one and one half times the cargo of the C-97. The first consequential flight in a C-124 made by the 116th happened in March 1967 when a Joint Chiefs of Staff mission was completed to Spain. The 116th maintained a schedule of three flights a month to Southeast Asia. (Courtesy of the Historical Society of the Georgia National Guard.)

The C-124 earned the nickname "Old Shaky" because it tended to shake quite a bit even in calm skies. Many pilots described the sound as a creaking and groaning, almost like the craft had arthritis and a bad back. The Air Force began using them for heavy lift cargo operations during the Korean War in 1952. (Courtesy of the Historical Society of the Georgia National Guard.)

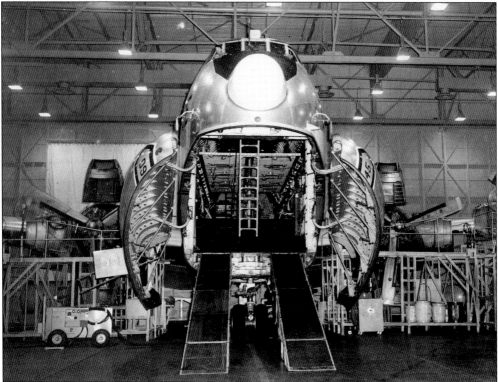

Lt. Col. Cleveland Perkins was the commander of the 116th Military Airlift Group when it became the first Air Guard unit to fly the C-124 to Vietnam. "Except for not being pressurized, the C-124 is better in every way than the C-97 for our mission," Colonel Perkins said. Pictured is a C-124 with its bay door open and ramp down as cargo is prepared to be loaded. (Courtesy of the Historical Society of the Georgia National Guard.)

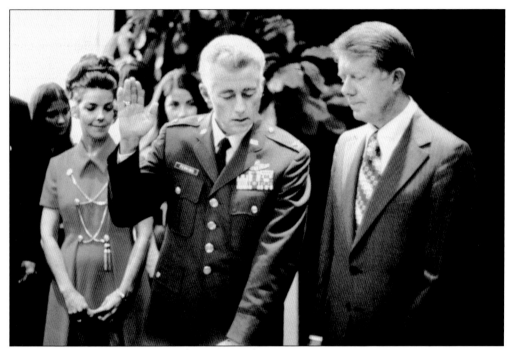

On November 25, 1971, Gov. Jimmy Carter (right) appointed Col. Cleveland J. Perkins (left) to replace Brig. Gen. Joel Paris as commander of the Georgia Air National Guard. Perkins, who was promoted to brigadier general, enlisted in the Army Air Corps in 1943 and served as a crew member on a B-24 where he completed 16 combat missions over Germany. After joining the Georgia Air National Guard, Perkins eventually commanded the 116th Fighter Group and 116th Military Airlift Group. (Courtesy of the Georgia National Guard History Office.)

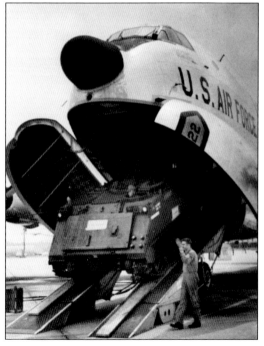

The C-124 was an impressive airlift flying machine, as evidenced by the cargo being loaded in this photograph—a Georgia Army National Guard tank. Cooperation with the Army was common relative to the C-124. In October 1968, an electronic satellite tracking station was the cargo for a Georgia Air National Guard C-124 that flew all the way to Darwin, Australia. The equipment was to be used by the Army Mapping Service. (Courtesy of the Historical Society of the Georgia National Guard.)

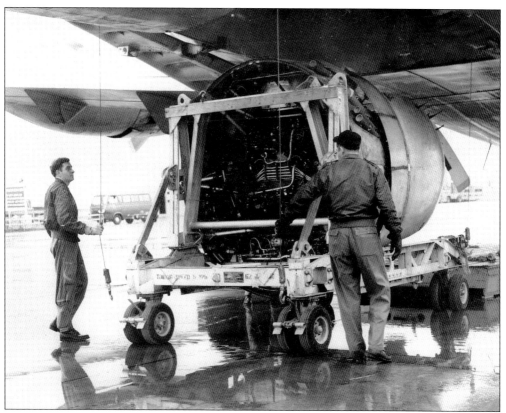

Loadmasters at Dobbins Air Force Base secure C-124 engines in 1969. The 116th Supply Squadron took over primary supply point responsibility for all C-124 aircraft late in the year. The tasks included requisitioning, shipping, and receiving serviceable and repairable parts and building up C-124 engines from locations all over the world. (Courtesy of the Historical Society of the Georgia National Guard.)

The Military Airlift Command officially rated the 116th Military Airlift Group with a C-1 distinction in November 1968. C-1 is the highest category of operational readiness possible under the rating system of the command. The 116th was the first of the Air Guard's nine C-124 groups to achieve the rating. Lt. Col. William R. Hudson was the commander of the 116th Military Airlift Group at the time. (Courtesy of the Historical Society of the Georgia National Guard.)

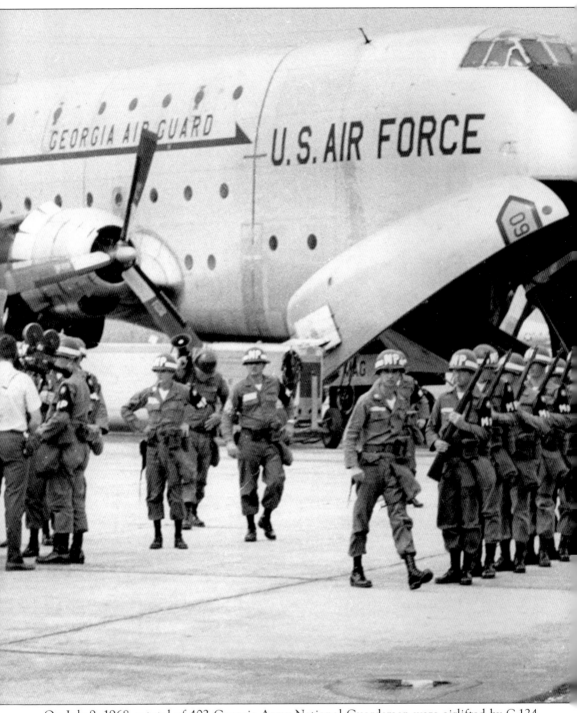

On July 9, 1968, a total of 402 Georgia Army National Guardsmen were airlifted by C-124 Globemasters from the pine tree-covered woods at Fort Stewart, near Hinesville, Georgia, to Dobbins Air Force Base as part of training exercises for the Georgia Emergency Operations Headquarters. Seven C-124s were used—four airlifted 33 jeeps and 2.5-ton trucks, and three aircraft carried the personnel. It was the first type of this exercise ever conducted in Georgia. The purpose

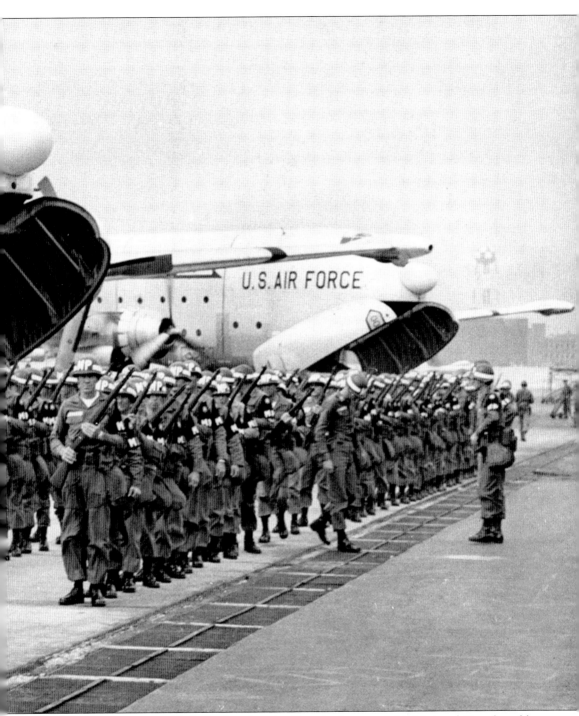

of the exercise was to establish the fact that the Georgia Army and Air National Guard could work together in carrying out the airlift of military police personnel in a state emergency. The exercise was successful. Pictured is the conclusion at Dobbins where the military police marched to a cordoned off area and practiced riot control formations. (Courtesy of the Historical Society of the Georgia National Guard.)

Sen. Sam Nunn was a frequent visitor to Dobbins Air Force Base during his service to Georgia. Here, he is addressing senior officers of the Air National Guard and the Air Force Reserve. During his tenure, Senator Nunn served as chairman of the US Senate Committee on Armed Services. He retired in 1994. The Sam Nunn School of International Affairs at the Georgia Institute of Technology was named in his honor in 1996 as he joined the university as a distinguished faculty member. (Courtesy of the Historical Society of the Georgia National Guard.)

The last C-47, affectionately known as the "Gooney Bird," in the Air National Guard inventory took its final flight at Dobbins Air Force Base on August 1, 1973. The crew aboard were Col. William H. McVey, senior Air Force advisor; Lt. Col. Rederick A. Davis, Air Operations officer, Headquarters, Georgia Air National Guard; and TSgt. Lebraun Arnold, crew chief. (Courtesy of the Historical Society of the Georgia National Guard.)

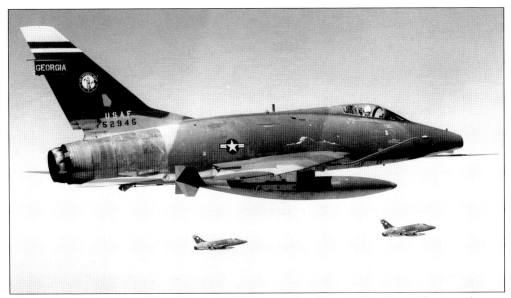

The 116th Tactical Fighter Wing flew the F-100 Super Sabre from 1973 to 1979. The aircraft was a single-seat, iron-bomb, mission-capable aircraft. (Courtesy of the Historical Society of the Georgia National Guard.)

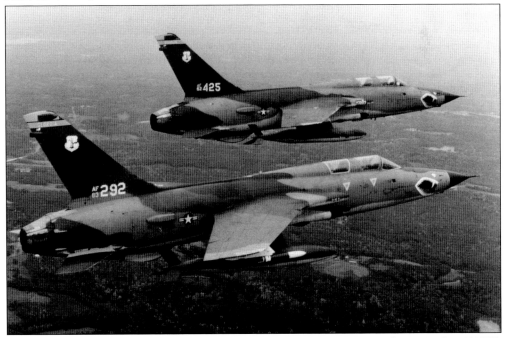

With the 116th Tactical Fighter Wing's conversion from the F-100 Super Sabre aircraft to F-105G "Wild Weasel" aircraft in September 1979, the mission of the organization changed dramatically. The aircraft required two members to serve in an electronic defense suppression role. The complexity of the mission necessitated a rigorous new training initiative. There was no electronic warfare training range nearby so the unit sought out opportunities to participate in all possible exercises where electronic threat signals were in use. (Courtesy of the Historical Society of the Georgia National Guard.)

Training in the F-105G featured memorable exercises, including the infamous QUICK THRUST 80-1. The unit's aircrews successfully completed the unit's mission by suppressing simulated enemy radar and surface-to-air missile installation. The end result was that a clear path was created for Air Force and Marine Corps personnel. Additionally, personnel from the Army National Guard's 48th Infantry Brigade were dispatched under fire cover from aircraft from Myrtle Beach Air Force Base, South Carolina. One of the reasons for the exercise was to perfect the coordination of the 48th and its air cover for an actual combat situation. A pivotal element of the exercise was the participation of the 129th Tactical Control Flight based in Kennesaw, Georgia. The air controllers of the unit were successful in their objective to direct a wide array of varied aircraft through the busy, crowded skies by proper employment of their sophisticated radar and communications. (Courtesy of the Historical Society of the Georgia National Guard.)

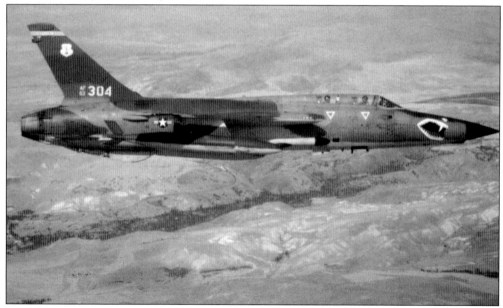

Pictured is the "Wild Weasel" on a training flight over Turkey. In 1980, the 116th deployed to Turkey for mission training shortly after a military coup. Turkish soldiers were on every street corner with automatic weapons and trucks at the ready. Wing personnel operated out of a "tent city" at Mürted Air Base in Turkey. (Courtesy of the Historical Society of the Georgia National Guard.)

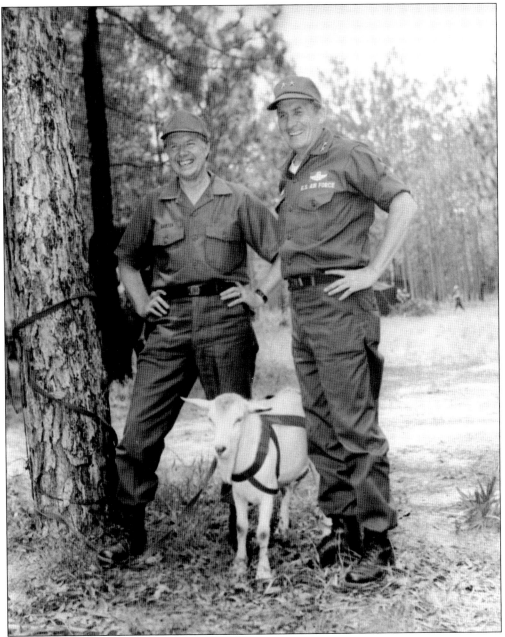

Gov. Jimmy Carter (left) and the Adjutant General of Georgia, Maj. Gen. Joel Paris (right), observe summer training camp in the mid-1970s. The unidentified goat was apparently a mascot of the troops. In 1976, Carter was elected president of the United States. (Courtesy of the Historical Society of the Georgia National Guard.)

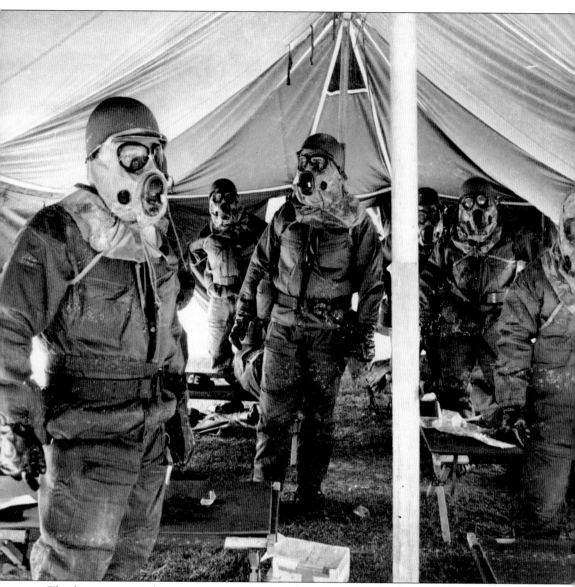

The disaster preparedness program was developed in greater detail and comprehensiveness during the Cold War in the military, including the Air National Guard. The threat of a Soviet nuclear attack as well as chemical warfare and natural disasters require adequate training opportunities. This includes the use of protective clothing, shelters, and decontamination procedures. In the photograph, members of the 116th don protective clothing during annual summer training. (Courtesy of the Historical Society of the Georgia National Guard.)

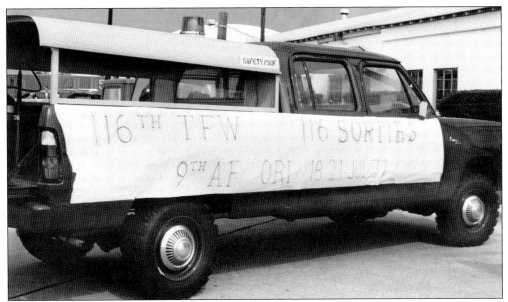

ORIs (Operational Readiness Inspections) are conducted to evaluate and measure the ability of a unit to perform in wartime during a contingency or a force sustainment mission. Accordingly, every wing undergoes an ORI approximately every five years. The 9th Air Force conducted an ORI in July 1977 for the 116th Tactical Fighter Wing. In military aviation, a sortie is a combat mission of an individual aircraft, starting when the aircraft takes off. For example, one mission involving six aircraft would tally six sorties. The sortie rate is the number of sorties that a given unit can support in a given time. The banner on this truck is quite revealing. Apparently, the number of sorties for this ORI matched the wing numerical designation. Was it happenstance or planned? (Courtesy of the Historical Society of the Georgia National Guard.)

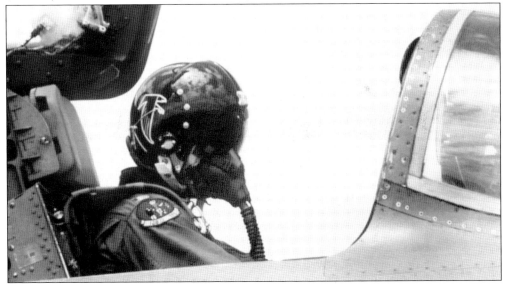

Pictured is a close-up view of a pilot with the 116th Tactical Fighter Wing in his F-105 Delta Dart aircraft as he prepares to depart for a training mission. Take note of the emblem on the side of his helmet—a tribute to the Atlanta Falcons football team, a member of the National Football League. (Courtesy of the Historical Society of the Georgia National Guard.)

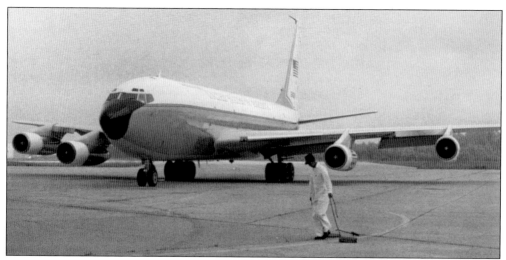

On April 23, 1976, Air Force One touches down at Dobbins Air Force Base with Pres. Gerald Ford on board. Each of the current (2023) Air Force One aircraft is equipped with classified security and defense systems, including measures to protect onboard electronics against the electromagnetic pulse of a nuclear explosion. A telecommunications center is located in the upper level, and the middle level contains accommodations for as many as 70 passengers. The total number of crew members is 26 individuals. (Courtesy of the Historical Society of the Georgia National Guard.)

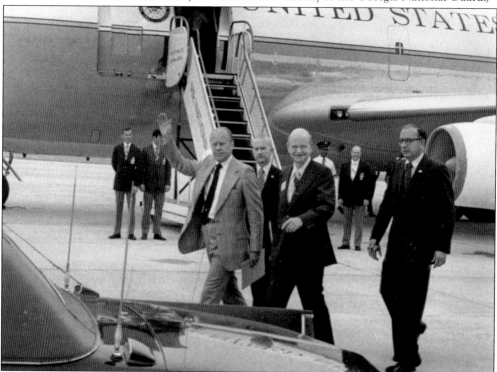

Pres. Gerald Ford is pictured waving during a visit to Dobbins Air Force Base on April 23, 1976. He is accompanied by Sen. Jesse Helms (right) and others. The president paused to speak with members of the media before being greeted by Dobbins military leadership. (Courtesy of the Historical Society of the Georgia National Guard.)

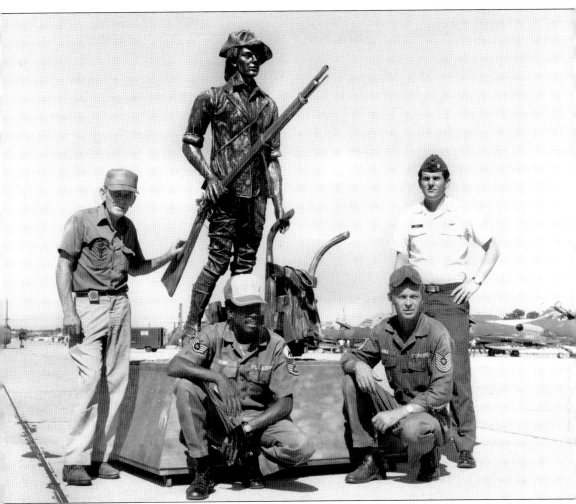

Georgia Guardsmen constructed this minuteman statue. Pictured are, from left to right, a Mr. Coker, Staff Sergeant Kemp, Master Sergeant Cole, and Maj. Bill Ridley. The 116th Tactical Fighter Wing's US bicentennial committee was cochaired by Ridley and Capt. Robert Cochran. Additional members were Maj. Gordon Moore, SMSgt. Robert Chandler, SMSgt. Jim Jordan, MSgt. William Anderson, MSgt. Rufus Bryant, and Becky Brown. One of the committee's projects was the construction of the statue, which was created using a manikin, an old Air Force uniform, and lumber. When completed, the statue was used on a float that participated in several 1976 bicentennial year parades. (Courtesy of the Historical Society of the Georgia National Guard.)

This caricature depicts Rojo the rooster, who became somewhat of a legend to members of the 116th Tactical Fighter Wing. Units of the wing were deployed to Travis Field in Savannah in October 1976 for annual field training under the command of Col. James R. Mercer. In civilian life, Mercer managed a poultry-producing company in Gainesville, Georgia. Several officers decided to purchase a rooster to give to the commander when he arrived at Travis Field. Colonel Mercer named the rooster Rojo. (Courtesy of the Historical Society of the Georgia National Guard.)

Rojo the rooster was similar in appearance to this north Georgia rooster. Rojo took on the duties of official mascot for the 116th Combat Support Group. Eventually, he was retired to a chicken ranch in northern Cobb County, Georgia. (Author's collection.)

Six

THE 1980S AND 1990S

When the last F-100 Super Sabre left the runway at Dobbins Air Force Base, it meant the ushering in of a new era for the 116th Tactical Fighter Wing as it converted to the F-105G "Wild Weasel" aircraft. Two-member crews carried out an electronic defense suppression mission.

The 116th Tactical Fighter Wing's next conversion was to the F-4D Phantom aircraft on September 1, 1983. The wing pursued every possibility to enhance its combat training, including the CORONET METEOR training exercise. "Prime Beef" (Base Engineer Emergency Force) teams of the 116th Civil Engineering Squadron performed rapid runway repair at Eglin Air Force Base. The exercise was completed in winter of 1987 and included the construction of a mobile aircraft arresting system and installation of runway lighting.

The Georgia Air National Guard's 111th Tactical Air Control Party was created in July 1988, and it was eventually renamed the 165th Air Support Operations Squadron (ASOS). The unit's responsibility is to plan and integrate close air support with Army scheme of maneuver on the battlefield. The 165 ASOS has undergone several conversions and has been located in different places, concluding with Savannah, Georgia. In August 1990, the 116th Tactical Fighter Wing began major preparation for possible mobilization for DESERT SHIELD and DESERT STORM. Persian Gulf intelligence briefings were given to all wing personnel for the remainder of 1990. The 165th Airlift Wing sent volunteer aircrews to stateside support duties as well as support flights in the United Arab Emirates. Many more unit members deployed in technical support positions in the United States and Europe.

Georgia Air National Guardsmen served with distinction in various roles, including security during the Centennial Olympics Games in the summer of 1996. A complex communications network was established that connected venues in Atlanta, Savannah, and Columbus.

In 1999, the VOLANT OAK mission at Howard Air Base in Panama came to an end as the handover of the Panama Canal from the United States was imminent. In fact, 45 members of the Georgia Air National Guard participated in the closing ceremonies. It was the Air National Guard's longest-running airlift operation. It rotated portions of Air National Guard (including the 165th Airlift Wing) and Air Force Reserve C-130 units to Panama on short tours of active duty to meet the theater airlift requirements of the United States Southern Command in Latin America.

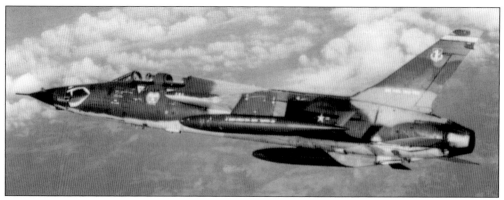

Pictured are two F-105G "Wild Weasel" aircraft in flight over Georgia. The 116th Tactical Fighter Wing staged a daylong operation dubbed "Gang Busters XI" in 1982 that simulated a real wartime environment. It included mock sniper infiltration, crashed aircraft, unexploded bombs, and nuclear contamination. The pilots joined with Air Force Reserve, Navy Reserve, and Marine Reserve aircraft to fight a mock battle over the Caribbean and the Atlantic Ocean. The showstopper was the participation of sophisticated Airborne Warning and Control System (AWACS) aircraft from Tinker Air Force Base, Oklahoma. (Courtesy of the Georgia National Guard History Office.)

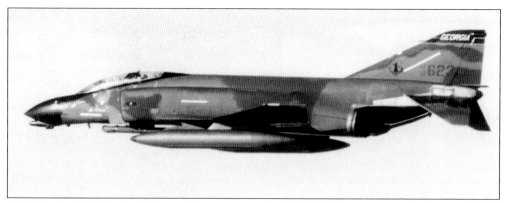

In 1983, the 116th Tactical Fighter Wing converted to the F-4D Phantom aircraft (pictured). The Phantom is a twin-engine, all-weather, Mach 2 class, tactical fighter-bomber. It has three tactical roles—interdiction, close air support, and air superiority. It can carry conventional weapons and laser-guided bombs. (Courtesy of the Historical Society of the Georgia National Guard.)

The F-4D Phantom mission created superior interface between the aircrews and the maintenance personnel. In fact, the mission capable rate average increased to more than 20 percent. In this image, three maintenance airmen inspect the F-4D Phantom after a training flight. (Courtesy of the Georgia National Guard History Office.)

The 116th Tactical Fight Wing's conversion to the F-4D Phantom necessitated the early arrival of one of the planes from Korea so that maintenance personnel could begin hands-on training. This crew member inspects the bottom of the recently arrived F-4D Phantom. Formal upgrade training took place at McConnell Air Force Base in Kansas and at Homestead Air Force Base in Florida in the fall of 1982. (Courtesy of the Georgia National Guard History Office.)

The 129th Tactical Control Squadron was located in Kennesaw, Georgia, where the author stands at the front gate. Its mission was to organize, equip, and train assigned personnel to effectively deploy and operate a Control and Reporting Post in combat theater. Through the use of assigned radars, communications equipment, vehicles, and support equipment, the unit was tasked to provide air defense and centralized airspace control of the combat zone. (Author's collection.)

Pictured is the 129th Tactical Control Squadron's radar operations section in the early 1990s. It included more personnel than any other section. The scope operators and plotters were essential to completing the squadron's mission. They were a varied group with a wide array of experience both military and civilian. Unit Training Assembly weekends were very busy eight to nine hour days without almost no down time. (Author's collection.)

The radar equipment of the 129th Air Control Squadron is pictured set up during field training. Summer camps were usually conducted in Savannah, Georgia, or Mississippi. The training included tactical mission control, navigation, air rescue assistance, threat warning, and coordination with artillery warning control centers. (Courtesy of the Georgia National Guard History Office.)

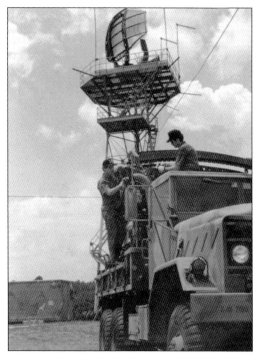

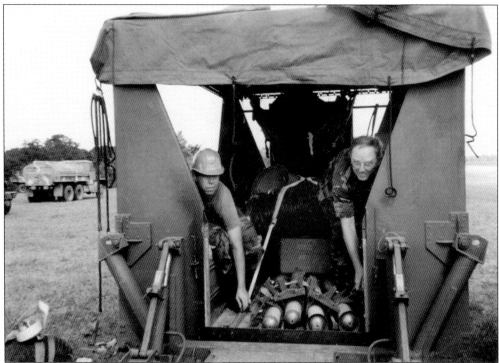

As a highly mobile radar operations unit, the coordination, planning, and logistics of such training for the 129th Air Control Squadron were key components of being prepared for a real-world deployment. TSgt. Gerald Wright (right) leads his team in setting up a segment of the operations center. This training took place in Biloxi, Mississippi, in the late 1980s. (Author's collection.)

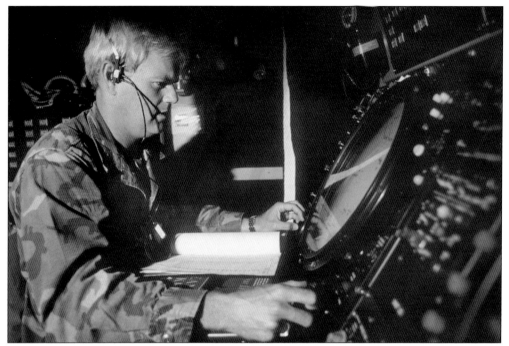

Maj. John Patrick of the 129th Tactical Control Squadron monitors a radar screen during the NATO exercise Tactical Fighter Weaponry in 1989. In 1992, the unit was redesignated as the 129th Air Control Squadron. (Courtesy of the Historical Society of the Georgia National Guard.)

SMSgt. Charles Mazariegos speaks at a patriotic event on the campus of Georgia State University in 1990. Mazariegos was the first sergeant of the 129th Tactical Control Squadron. In 1965, he joined the US Marine Corps. He served in Vietnam in 1967 and 1968 where he received his highest military decoration, the Purple Heart. On August 27, 1968, he was wounded during an attack where 24 other Marines were killed while at Camp J.J. Carroll, south of the demilitarized zone. He was treated at a hospital in Vietnam and was in the field again in two days. (Author's collection.)

In 1991, the 129th Tactical Control Squadron returned to Denmark for a second time. Most of the mission exercise activities took place near the small town of Nymindegab on the west coast of the nation (pictured here). The 118th Tactical Control Squadron, sister unit of the 129th Tactical Control Squadron and colocated at the Kennesaw facility, deployed three times to Denmark with the 129th Tactical Control Squadron. (Author's collection.)

During the mission exercises to Denmark, most members were granted several off duty days. A small group made the long cross-country trek to the historic and romantic city of Copenhagen, the capital of Denmark as well as the most populated area. (Author's collection.)

In 1995, the 129th Tactical Control Squadron participated in exercise ROVING SANDS at White Sands Missile Range in New Mexico. The world's largest air and missile defense exercise, ROVING SANDS' emphasis is on the joint and combined interoperability of joint forces air component command (JFACC), joint missile defense command, and air area defense command. ROVING SANDS 95 involved German and Dutch air defense units and provided invaluable interoperability training with the air defense forces of those two nations. (Author's collection.)

The 129th Air Control Squadron was the only unit in the Georgia Air National Guard to retain the original boar's head, the symbol of the first Georgia Militia, as part of its official emblem. The boar's head was part of Gen. James Oglethorpe's family coat of arms, and it was the official emblem of the early militia. It is used by all Georgia Army National Guard units. (Author's collection.)

The 118th Air Control Squadron's history and legacy were intertwined with the 129th Air Control Squadron in numerous ways. The 118th Air Control Squadron was assigned to the 129th Air Control Squadron whereby it carried out its mission to deploy a forward air control post to a combat zone and utilize its radar and communications equipment to act as a forward extension for larger radar control units such as the 129th Air Control Squadron. The image captures the official inactivation ceremonies for the 118th Air Control Squadron at its McCollum Parkway location in Kennesaw in December 1995. In the background row are, from left to right, Lt. Col. Roy Goodwin, William Bland (adjutant general of Georgia), Maj. Gen. Michael Bowers, Brig. Gen. Douglas Padgett, and CMSgt. Chester Nabors. The 129th Air Control Squadron was officially inactivated on September 22, 1996. (Courtesy of the Historical Society of the Georgia National Guard.)

The 165th Air Support Operations Squadron was activated for DESERT STORM and deployed to Fort Irwin, California, for training, but the hostilities ended quickly. The unit has participated in over 220 exercises, including numerous Army and Air Force exercises in various locales. The unit's nickname is the "Snake Eaters." In military circles, the moniker refers to a highly skilled and resourceful individual who possesses exceptional survival skills and operates independently in hostile environments. (Courtesy of the Historical Society of the Georgia National Guard.)

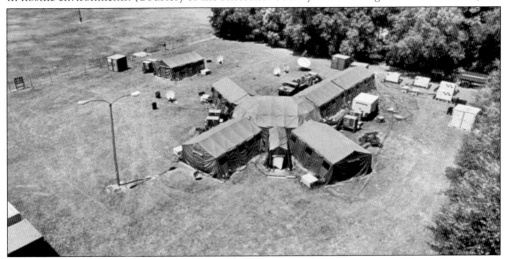

The renowned Joint Communications Support Element (JCSE) was established as a dedicated communications resource for short-notice contingency operations. The JCSE was established at MacDill Air Force Base in Florida. In 1985, Brunswick, Georgia's 224th Joint Communications Support Squadron received new state-of-the-art equipment, and it was promptly directed to affiliate with JCSE. (Courtesy of the Historical Society of the Georgia National Guard.)

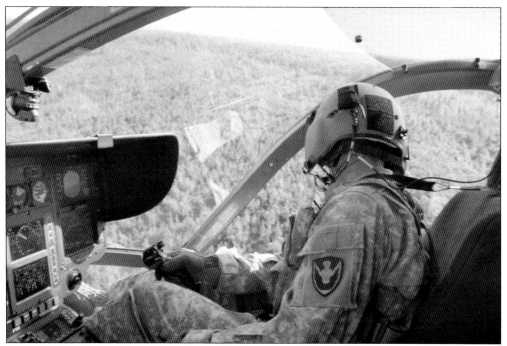

On September 18, 1989, Secretary of Defense Richard B. Cheney issued the department's guidance for implementation of the president's National Drug Control strategy. The guidance included the use of armed forces in reducing the supply of illegal drugs (interdiction) and reducing demand for drugs. Out of this effort arose the utilization of the National Guard in the fight against illegal drugs, including use of helicopters for interdiction searches in rural areas of Georgia. (Courtesy of the Historical Society of the Georgia National Guard.)

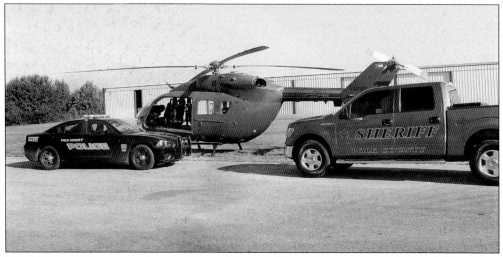

Lt. Col. Owen Ulmer served as the Georgia National Guard Counterdrug Task Force's first officer. As a member of the Air Guard, he commanded both Army and Air National Guard members who comprise the task force's staff. Ulmer coordinated efforts with law enforcement agencies throughout the state to remove illegal drugs from communities. The task force also focused on educating schoolchildren on the dangers of drugs and the benefits of a healthy lifestyle. (Courtesy of the Georgia National Guard History Office.)

The open ceremonies of the 1996 Centennial Olympic Games in Atlanta are pictured here. The games became the largest single peacetime domestic operation in the history of the National Guard. The Georgia National Guard served as the command and control element for more than 13,000 Army and Air National Guardsmen from 47 states and territories who provided support to local law enforcement. After winning an Olympic bid, the law enforcement agencies (in addition to its other public safety agencies and military forces) of the host country face the difficult task of planning security in the intervening six years. (Courtesy of the Georgia National Guard History Office.)

A Michigan Air National Guardsman directs traffic at the boxing venue during the 1996 Centennial Olympic Games in Atlanta. Both Army and Air Guardsmen from numerous states supported the effort to provide security and logistical support to the games. (Courtesy of the Georgia National Guard History Office.)

Lt. Col. Jimmy Davis (left) served as military venue officer at the Georgia Dome. Here, Brig. Gen. Walter Corish (right), assistant adjutant general/air, discusses plans with Davis. Risk management was a key focus for each Olympic military venue officer. Each venue was unique, yet there were several common hazards that could have happened at almost all of the locations. Georgia Guardsmen were the military venue officers for each individual competition location. They worked hand in hand with Atlanta Committee for the Olympic Games (ACOG) security managers and civilian law enforcement to provide security for the sporting events. (Courtesy of the Historical Society of the Georgia National Guard.)

Task Force 165 was commanded by Col. Steve Westgate, commander of the 165th Airlift Wing, to provide military support for Olympic events in the Savannah area. The task force also set up a satellite communications network to support the competition in several regions of the state. The 283rd Combat Communications Support Squadron administered the communications responsibility with the assistance of the 117th Air Control Squadron and the 224th Joint Communications Support Squadron. (Courtesy of the Historical Society of the Georgia National Guard.)

Gov. Zell Miller (right) called 725 Georgia Guardsmen to active duty to provide security for the Olympic Village following the Centennial Park bombing. Guardsmen were located at 43 competitive venues. Eleven base camps were created in the metro Atlanta area. (Courtesy of the Historical Society of the Georgia National Guard.)

Maj. Randy Scamihorn instructs on security requirements with Olympic volunteer Debra Johnson. The Olympic Games would not have been successful without the thousands of civilian volunteers who worked long hours. (Courtesy of the Georgia National Guard History Office.)

Lt. Col. Bill Ridley (left) of the 116th Bomb Wing discusses security measures at the equestrian venue with Capt. Ken Crick (right) of the Indiana Army National Guard in support of the Centennial Olympic Games in Atlanta. Coordination between military components and the personnel from states from across the country was crucial to success. (Courtesy of the Georgia National Guard History Office.)

Georgia Guardsmen assisted with traffic management, aviation support, vehicle and package sanitation procedures, and accreditation. Pictured is a Georgia Guardsman in the process of checking a civilian vehicle for potential explosives. The Georgia National Guard Emergency Operations Center was at work for 90 days in the summer of 1996. Many observers and commentators considered the work of the National Guard during the Olympic Games to be the organization's "finest hour." (Courtesy of the Historical Society of the Georgia National Guard.)

Seven

Post 9/11

Air National Guard fighters and tankers moved swiftly to protect Americans from additional attacks on September 11, 2001. Nineteen terrorists used four hijacked airliners to destroy the World Trade Center in New York City and damage the Pentagon. The attacks killed approximately 3,000 people. In response, nonstop combat air patrols were conducted over Washington, DC, and New York City until the spring of 2002. The majority of the missions, carried out under the banner of Operation NOBLE EAGLE, were flown by Air National Guard pilots.

Operation NOBLE EAGLE was defined as the objective "to provide additional authority to the Department of Defense . . . to respond to the continuing and immediate threat of further attacks on the United States . . . to order any unit, and any member of the Ready Reserve not assigned to a unit . . . to active duty for not more than 24 consecutive months."

In a public address soon thereafter, Maj. Gen. David Poythress, the adjutant general of the Georgia National Guard, stated, "We shall continue to march forward for as long as it takes to meet the challenges of this new and dangerous world. Our soldiers and airmen must go into the fray knowing full well that their families accept the hazards of the military profession, and that they understand the reason why we fight . . . to keep this nation free of fear for them and every citizen who wants to stride into the sunlight of freedom."

Two thousand Georgia National Guardsmen were dispatched to the disaster relief efforts after the destruction created by Hurricane Katrina in the Gulf of Mexico in August 2005. The Guardsmen focused on medical needs, airlift, security, engineering, and support operations.

In recent years, the Georgia Air National Guard has been tasked for domestic missions such as providing security at the southern border of the United States and maintaining peace in major cities during the riots of 2020. During the COVID-19 pandemic, Gov. Brian Kemp of Georgia activated the National Guard to support health care professionals and local government officials.

The Air National Guard has a unique dual mission that consists of state and federal roles. The upcoming years will undoubtedly prove to be perilously challenging. A well-trained Georgia Air National Guard is prepared to meet the challenges with courage and professionalism.

In the months following the 9/11 terrorist attacks, Georgia Air National Guardsmen responded in the spirit of the Air Force's core values: "Service before Self, Integrity First, Excellence In All We Do." Operations NOBLE EAGLE, ENDURING FREEDOM, and IRAQI FREEDOM placed a burden on military reserve components. The Georgia Air Guard contributed tremendously. Pictured is CMSgt. Charles Mazariegos of Headquarters, Georgia Air National Guard. He volunteered for active duty service with Army and Air Force units in Iraq. He is pictured standing in front of the Division Chapel in Baghdad. (Author's collection.)

Pres. George W. Bush ordered the National Guard from around the country to serve as security at commercial airports after September 11, 2001. In Georgia, Army and Air Guardsmen assembled at the Combat Readiness Training Center near the Savannah International Airport for three days of training. In conjunction with the Federal Aviation Administration, the personnel trained on firing 9-mm semiautomatic weapons and proper search and seizure techniques. The Guardsmen were assigned to airports throughout the state, including Atlanta's Hartsfield International Airport, Brunswick, Albany, Rome, Savannah, and Dalton. The mission was dubbed "Operation Sky Guard." (Courtesy of the Historical Society of the Georgia National Guard.)

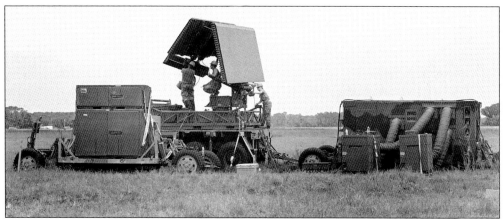

The 117th Air Control Squadron was one of the first units to be activated in the aftermath of September 11. Controlling the airspace over any given battlefield is the unit's primary responsibility. Its mobile antennas and monitoring equipment can detect aircraft from the ground to tens of thousands of feet above the ground. The squadron was called upon to put these skills to practical use to assist in protecting US cities from the threat of terrorism in the skies. During the 2000s, the 117th Air Control Squadron deployed numerous times to provide air defense for the Space Shuttle program at Cape Canaveral, Florida. (Courtesy of the Historical Society of the Georgia National Guard.)

Two hundred members of the 224th Joint Communications Support Squadron based in Brunswick were called to active duty on September 22, 2001, as part of Operation ENDURING FREEDOM. Their mission was to provide communications between the Joint Special Operations Task Force commander in the Southwest Asia theater of operations and the commander in chief of Central Command and Special Operations Command in the United States. The unit establishes reliable communication for special forces units in the field in order to give them intelligence data, voice, and fax capabilities. (Courtesy of the Historical Society of the Georgia National Guard.)

After September 11, 2001, the majority of the 165th Air Support Operations Squadron deployed to Iraq and Afghanistan in support of Operations ENDURING FREEDOM and IRAQI FREEDOM. Several members of the 165th Air Support Operations Squadron were nominated for recognition due to their brave actions. (Both, courtesy of the Historical Society of the Georgia National Guard.)

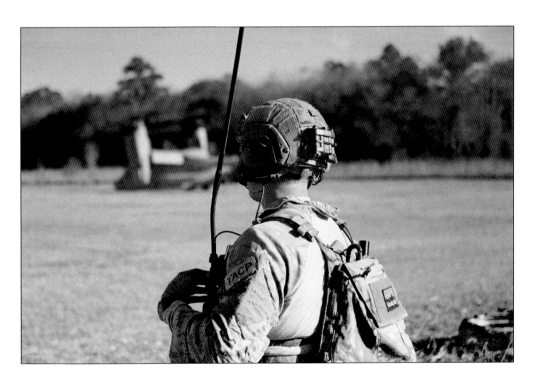

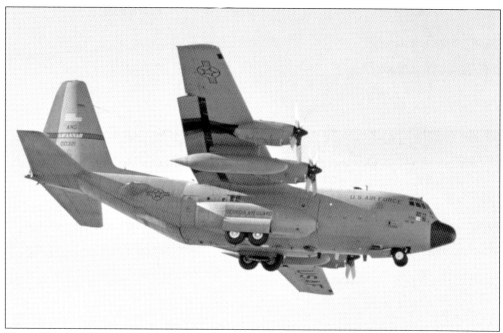

The 165th Airlift Wing has been actively engaged in the war on terror. Within 72 hours after September 11, the unit provided critical airlift support for Operation NOBLE EAGLE. Aircrews worked 18–20 hour days. Sixty members of the wing's Security Police Squadron were mobilized for two years. (Courtesy of the Historical Society of the Georgia National Guard.)

Members of the 116th Air Control Wing deployed in the US Central Command's area of responsibility in support of Operation IRAQI FREEDOM. Hundreds of sorties were flown with some of the missions lasting upwards of 17 hours. The task was to provide real-time battlefield information to commanders on the ground from the JSTARS aircraft (pictured). At the height of operations, more than 600 members of the wing deployed. (Courtesy of the Historical Society of the Georgia National Guard.)

In 1997, the Georgia General Assembly created a study committee on the Georgia National Guard's future mission requirements. It was charged with studying the challenges and opportunities that the Guard faced in the future and how the legislature could support the organization. Three of the participants were Georgia National Guard members as well as legislators. Pictured are, from left to right, Rep. Ron Crews (Georgia Army Guard), Sen. Terrell Starr, Sen. Mike Crotts, Maj. Gen. William Bland (the adjutant general of Georgia), Sen. Jack Hill (Georgia Air Guard), Sen. Ed Harbison, Rep. Clint Smith (Georgia Air Guard), and Sen. Pam Glanton. (Author's collection.)

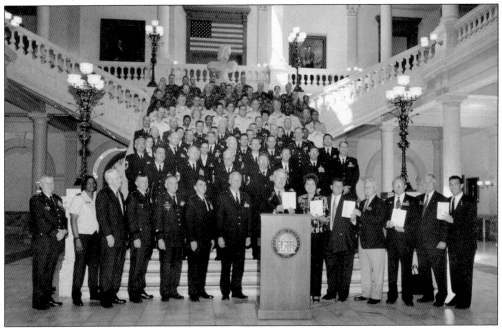

In 2002, the Georgia legislature passed a bill that created a state retirement supplement for qualified Georgia National Guardsmen. Maj. Gen. David Poythress, the adjutant general (immediate left of podium), was instrumental in the passage of the bill. He led a group of Georgia Guardsmen to the Georgia State Capitol for the signing ceremony. (Author's collection.)

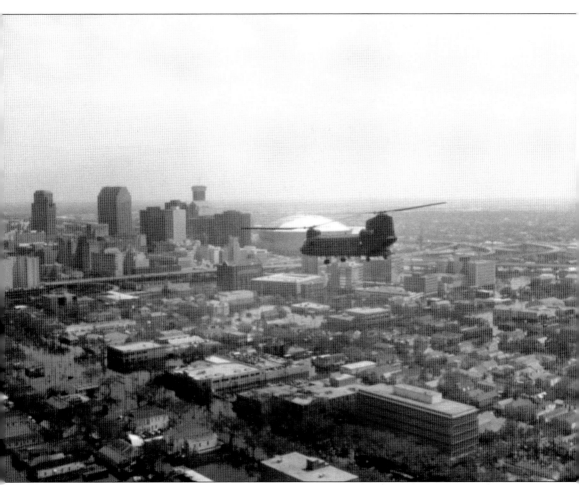

On Friday afternoon, August 26, 2005, the path of Hurricane Katrina made a dramatic shift to the west. New Orleans was the projected target for a direct hit by what was considered a Category 5 hurricane. Almost 1.5 million people were evacuated from southern Louisiana in approximately 36 hours. On Monday, August 29, 2005, Katrina made landfall. Tidal surges flooded St. Bernard and Plaquemines, the parishes located to the south of New Orleans. The surge stretched eastward through Mississippi where it was recorded at 30 feet in one location. In total, Katrina impacted 90,000 square miles of land. Multiple levees installed to protect New Orleans breached on August 29, 2005. Eighty percent of the city of New Orleans was engulfed in floodwaters. Louisiana lost approximately 80 percent of its economy. (Courtesy of the Georgia National Guard History Office.)

The destruction and chaos created by Hurricane Katrina required numerous federal and state agencies to respond. The Georgia National Guard (Army and Air) was a valuable contributor to the recovery process. (Courtesy of the Georgia National Guard History Office.)

The 116th Air Control Wing and the 165th Airlift Wing Security Police Squadrons were mobilized. Some of these personnel were airlifted by C-130 Hercules cargo aircraft flown by Savannah's 165th Airlift Wing. Also, many civilian evacuees from the New Orleans area were flown into Dobbins Air Reserve Base. The evacuee mission at the base was organized and staffed by members of Headquarters, Georgia Air National Guard and others. Pictured are airmen preparing for medical evacuee procedures. (Courtesy of the Historical Society of the Georgia National Guard.)

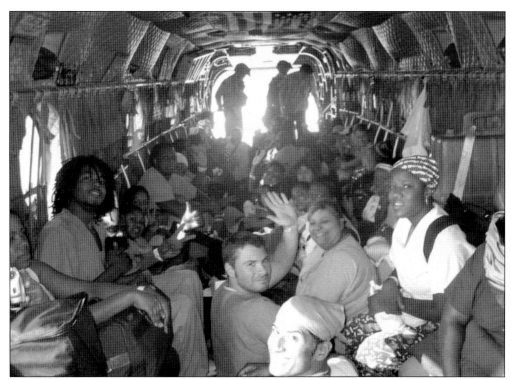

Georgia Air National Guard units were asked to provide volunteers to support Hurricane Katrina relief efforts. The 165th Airlift Wing tasked 28 vehicles and 105 personnel to deploy to Camp Shelby in Mississippi. The 116th Air Control Wing tasked 47 vehicles and 120 personnel to the same location. Upon arrival, 18 aerial port, 10 CRTC-Savannah, 2 PERSCO, 10 vehicle maintenance, and 40 medical personnel completed duty assignments in their trained areas of knowledge. The rest of the personnel assisted in miscellaneous other jobs, including loading water and MREs (Meals Ready-to-Eat) aboard helicopters for distribution to civilians. (Courtesy of the Historical Society of the Georgia National Guard.)

The Adjutant General of Georgia, Maj. Gen. David Poythress (left), and Gov. Sonny Perdue (right) are briefed by a government official in the aftermath of Hurricane Katrina. The topic is medical evacuations from New Orleans. (Courtesy of the Georgia National Guard History Office.)

Georgia National Cemetery in Canton is the second national cemetery in Georgia and the final resting place for many National Guardsmen as well as veterans of all other military components. Real estate developer Scott Hudgens, a veteran, donated the 775-acre site to the National Cemetery Administration in 2001. In 2006, Georgia National Cemetery opened for burials and was formally dedicated on June 4 of that year. (Courtesy of the Georgia National Guard History Office.)

The Georgia National Guard provides professional and dignified military funeral honors to eligible veterans. The Guard offers a selection of honors that include flag folding, the playing of "Taps," pallbearers, rifle volley, and more. Georgia National Cemetery (pictured) as well as numerous other cemeteries throughout Georgia have been the sites of many military funeral honors. (Author's collection.)

The Georgia Air National Guard activated the 139th Intelligence Squadron at Fort Gordon in Augusta, Georgia, on May 29, 2008. The new unit's federal mission was to execute cryptologic intelligence operations to satisfy strategic, operations, and tactical intelligence requirements of national decision makers. The state mission was to provide military forces that are trained and equipped to assist the citizens of the state in an emergency. (Courtesy of the Georgia National Guard History Office.)

Georgia Air National Guardsmen assigned to the 165th Air Support Operations Squadron teamed up with soldiers from the 48th Infantry Brigade of the Georgia Army National Guard in Nangarhar Province, Afghanistan, in late 2009. The airmen were assigned to several joint terminal attack controller units that called in combat-air support for the 48th's fighters, according to Capt. Roger Brooks IV, the commander of the Georgia Joint Terminal Attack Controller (JTAC). (Brooks is pictured in foreground with US Army specialist Brett Bentley, Troop A, 1st Squadron, 108th Calvary Regiment, who provides security.) Brooks described his team as an "in-case-of-emergency-break-glass" option. The controllers served with the advancing infantry, assessing the situation alongside the combat troops and calling in air support if the situation dictated. Georgia's JTACs were divided into three-man teams spread among four battalions conducting battlefield operations. (Courtesy of the Historical Society of the Georgia National Guard.)

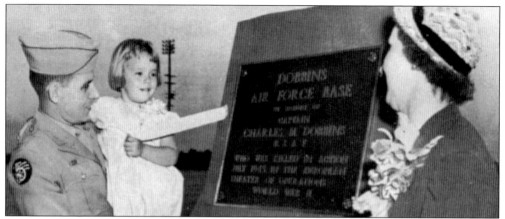

During World War II, Marietta Army Air Field hosted the Bell Bomber plant. With more than 28,000 workers, the plant assembled the B-29 Superfortress. In 1948, the US Air Force renamed the facility Marietta Air Force Base and two years later changed it again to honor Marietta native Capt. Charles Dobbins. Dobbins was a Georgia Tech graduate who flew C-47 troop transport planes in Europe and North Africa. In July 1943, Dobbins's plane was shot down over Sicily on his 88th combat mission. The plane and crew were never found. Dobbins was awarded the Distinguished Flying Cross. His family was present when Dobbins Air Force Base was formally dedicated on April 29, 1950. Pictured from left to right are Capt. Patman Dobbins (Charles's brother); his niece Beverly; and his mother, Ethel Dobbins at the dedication ceremony on April 29, 1950. In 1992, the base was renamed Dobbins Air Reserve Base. (Courtesy of the Historical Society of the Georgia National Guard.)

Headquarters, Georgia Air National Guard functions as a command element, commanding all activities of Air Guard units in the state. The organization is responsible for writing plans for contingencies, natural disasters, civil disturbances, emergency communications, and mobilization of Air National Guard resources to active duty assignments. Staff assistance visits are scheduled each year for Headquarters staff to visit all units in Georgia. In January 1997, Headquarters moved from 935 East Confederate Avenue, SW in Atlanta to the Finch Building at Dobbins Air Reserve Base, Marietta, Georgia (named in honor of Maj. Gen. George Finch). Pictured is the Headquarters staff in the late 1990s. (Author's collection.)

The Lucius D. Clay National Guard Center was dedicated and opened in December 2011. The facility is named in honor of a Marietta native, Gen. Lucius D. Clay of the US Army. He is well known for his role in the successful Allied airlift of food and supplies into Berlin, Germany, during the Soviet blockade in the late 1940s. The Clay National Guard Center houses Headquarters, Georgia Air National Guard, as well as the adjutant general's office, Georgia Army Guard leadership, and Joint Forces Headquarters. It is located adjacent to Dobbins Air Reserve Base. (Author's collection.)

The Clay National Guard Center is located on the previous site of Naval Air Station Atlanta. The 107-acre station closed in 2009 due to decisions made by the Base Realignment and Closure Committee. The transition of the property to the Georgia National Guard came as a result of months of work by Gov. Sonny Perdue, Sen. Saxby Chambliss, Sen. Johnny Isakson, Congressman Phil Gingrey, and Congressman Tom Price. (Courtesy of the Historical Society of the Georgia National Guard.)

Operation Jump Start was a mission from 2006 through 2008 that marked the National Guard's continuing efforts to keep America's borders secure. Starting in June 2006 and lasting for over two years, 6,000 National Guard members, including Air and Army personnel from Georgia, at any one time participated in the mission in New Mexico, Arizona, Texas, and California to make the border more secure for legal immigration and commerce. Guard members did not serve in a direct law enforcement role but provided important reinforcements to the US Border Patrol. Their missions included engineering, aviation, and entry identification teams and administrative, technical, and logistical support. (Courtesy of the Georgia National Guard History Office.)

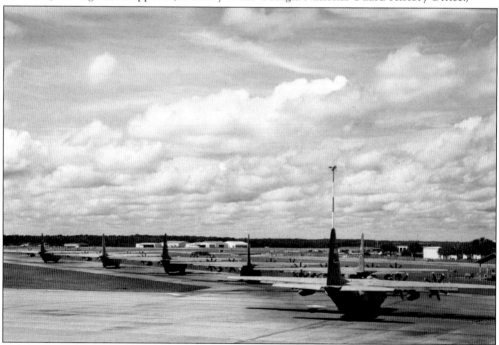

In November 2007, the final group of airmen from the 165th Airlift Wing returned from Afghanistan, ending a series of numerous rotations that lasted between 30 and 90 days. Over 65 airmen deployed where they assisted units from Alaska, Ohio, and Missouri in delivering supplies and food to Polish troops. It was one of the largest airdrops in an active combat zone in Air Force history. (Courtesy of the Historical Society of the Georgia National Guard.)

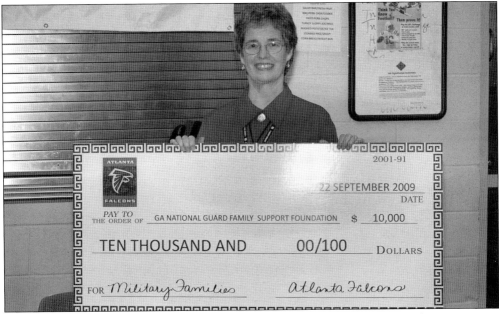

Harriet Morgan leads the Georgia National Guard Family Support Foundation. The organization is a self-funded charitable corporation established in 1994. The foundation's primary mission is to provide financial relief assistance during times of unexpected emergencies and hardships to current members of the Georgia National Guard and full-time federal/state civilian employees of the Georgia Department of Defense living in the state of Georgia. The Georgia National Guard Family Support Foundation relies totally on donations and fundraising events to support its mission. Here, Harriet Morgan holds a check for a generous contribution from the Atlanta Falcons of the National Football League. (Courtesy of the Georgia National Guard History Office.)

The Georgia Air National Guard basketball team played several games at Philips Arena, home of the Atlanta Hawks of the National Basketball Association. Pictured is action from a game played on March 13, 2010, at Philips Arena where they played the Georgia Army National Guard team. The Army team won 55-42. Ticket proceeds as well as a generous contribution from the Atlanta Hawks went to the Georgia National Guard Family Support Foundation. Members of the Air National Guard team were head coach Michael Rumsey, assistant coach Tekiya Green, and players James Reece, Calvin Wills, James Gatlin, Cyrus Champagne, Billy Carter, Prentiss Law, Clint Smith, Eric Smith, Dewayne Smith, Michael Roy, and Larry Green. (Courtesy of the Georgia National Guard History Office.)

In 2011, the Georgia Air National Guard supported WXIA Eleven Alive on Veterans Day as the media outlet presented a live telecast of a salute to military service program from the Georgia Dome

in Atlanta. Personnel from all military components participated. (Author's collection.)

The chapel at Dobbins Air Reserve Base served the spiritual needs of members of the Air National Guard and Air Force Reserve for 63 years at its location near the main gate. Originally, it was constructed and deployed to Europe during World War II. When the war ended, the building was acquired by the Georgia Air National Guard. In 1950, it was moved to Dobbins. At an opening ceremony, it was dedicated to veterans who served during World War II. The event was officiated by Brig. Gen. J.H. O'Neil, well known for writing Gen. George Patton's prayer for clear weather during the Battle of the Bulge. (Author's collection.)

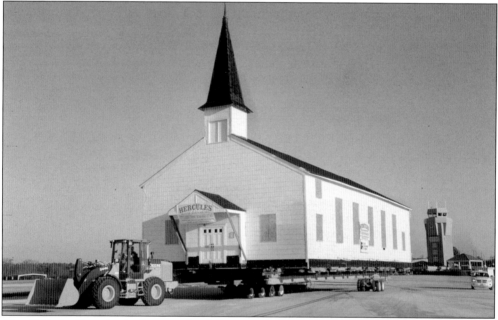

After 9/11, Air Force leadership mandated that most bases make security and logistical changes. As the chapel was so close to the main gate, it would have to be demolished or moved. Since Dobbins is a reserve base, funds are not authorized for any expenses relative to its function. The Dobbins Chapel Foundation was created as a nonprofit group in 2005 to raise funds for its move and upkeep. (Courtesy of the Historical Society of the Georgia National Guard.)

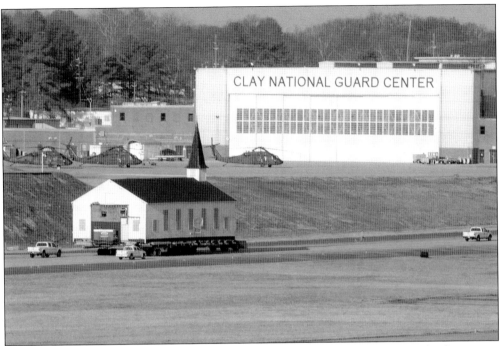

Due to the leadership of two retired members of the 116th Air Control Wing, Col. John Powers and CMSgt. Dick Roberts, along with additional members of the Dobbins Chapel Foundation, adequate funds were raised for a move of the building in 2013. Pictured is the chapel as it is moved across the Dobbins runway. (Courtesy of the Historical Society of the Georgia National Guard.)

The chapel's destination was a perfect location. The site of a former gas station, it sits across the street from the main Headquarters building at the Clay National Guard Center, which is colocated with Dobbins on the other side of the runway. The chapel will meet the spiritual needs of military personnel, families, and visitors for generations to come. (Author's collection.)

The Freedom Calls Memorial Foundation Wall is located in a place of appropriate reverence and prominence in front of the Joint Force Headquarters at the Clay National Guard Center in Marietta, Georgia. It was created to commemorate the service of members of the Georgia National Guard who lost their lives in the Global War on Terror. It includes granite plaques honoring each service member. The memorial is a special place for reflection and remembrance for both family members and the public. (Both, courtesy of the Georgia National Guard History Office.)

CMSgt. Percy Freeman of Headquarters, Georgia Air National Guard developed a mentorship program in the Georgia Air National Guard for young airmen to partner with more experienced members to augment their training, enhance their leadership traits, and to serve as advisors and confidantes in their career progression. In his military career, Freeman served under the commands of the legendary Gen. Daniel "Chappie" James and his son Lt. General Daniel James III, director of the Air National Guard. (Courtesy of the Historical Society of the Georgia National Guard.)

In March 2014, airmen from the 224th Joint Communications Support Squadron returned to Brunswick after six months of providing communication support to various missions in the US Central Command area of responsibility. The Brunswick-based unit had been continuously deployed in support of Operation ENDURING FREEDOM since November 2001, Operation IRAQI FREEDOM since March 2003, and the follow-on Iraq mission, Operation NEW DAWN, since September 2010. Members deployed to assist forces and units assigned to US Central Command, US Special Operations Command, and the International Security Assistance Force. (Courtesy of the Georgia National Guard History Office.)

Col. Joe Ferrero (Ret.), deputy adjutant general in the Georgia Department of Defense, was instrumental in working with the Georgia Governor's Office as well as the Georgia legislature to provide sorely needed improvements to National Guard facilities throughout the state. (Courtesy of the Georgia National Guard History Office.)

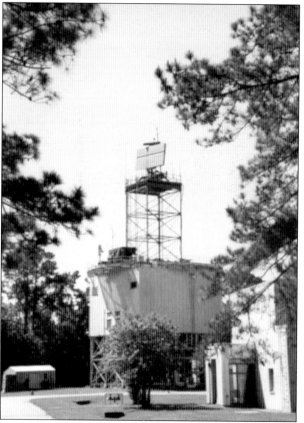

A large radar tower positioned at the 117th Air Control Squadron at Hunter Army Airfield in Savannah helps air battle managers and other weapons controllers take part in Sentry Savannah 2019. Members from the 116th Air Control Wing worked at the site during their two-week annual training as part of their pre-deployment training. (Courtesy of the Historical Society of the Georgia National Guard.)

The 530th Air Force Band was formed in the fall of 1946, and its original commander was CWO William F. Walker. Through the years, the organization has recruited an outstanding lineup of musicians. This early recruiting poster was one of the methods that the band utilized to get the word out that talent was needed to fill the ranks. It was placed in venues that professional musicians frequented. (Courtesy of the Historical Society of the Georgia National Guard.)

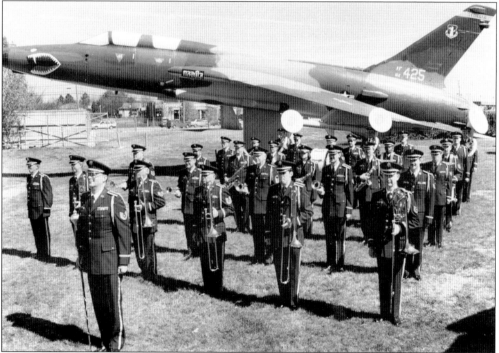

In 2002, the band's name was changed to the Air National Guard Band of the South. Pictured is a publicity photograph taken in the 1990s at the entrance of Dobbins Air Reserve Base. Within the band, there were several ensembles: marching/ceremonial band, the concert band, a rock-fusion band known as Sound Barrier, a Dixieland group called The Dixie Dudes, a Top 40 band known as Space A, and various brass and woodwind ensembles. The band was inactivated on October 1, 2013. Longtime member Margaret Banton said, "The contribution to patriotism and pride in our nation that the band was able to play a role in will always be a cherished memory." (Courtesy of the Historical Society of the Georgia National Guard.)

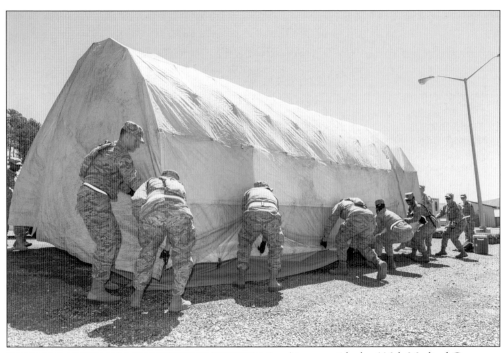

Airmen with the 116th Medical Group, Detachment 1 and the Georgia Army National Guard's 248th Medical Company move a portable medical tent during an exercise at Fort McClellan in Alabama in April 2016. The 116th Medical Group, Detachment 1 is part of the Region 4 Homeland Response Force whose mission is to provide a ready, responsive, and reliable team of military service members who provide a response capability to assist civil authorities in response to a chemical, biological, radiological, or nuclear incident. (Courtesy of the Georgia National Guard History Office.)

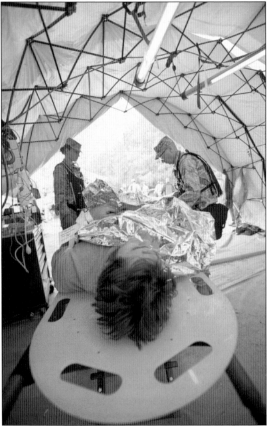

The 116th Medical Group and the 165th Medical Group are greatly respected in the Air Force medical community for their dedicated professionalism. Both units excel in training and real-life missions. This image shows 116th Medical Group personnel in action at a Homeland Response Force exercise in November 2011 at Camp Blanding Joint Training Center, Florida. (Courtesy of the Georgia National Guard History Office.)

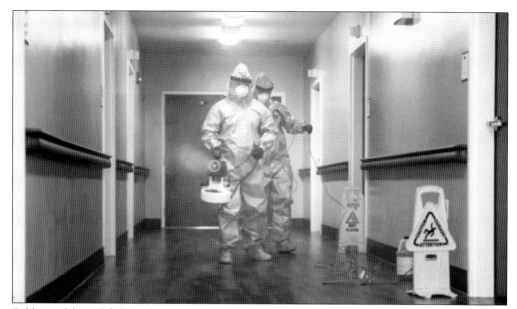

Soldiers of the 148th Brigade Support Battalion, Georgia Army Guard, and airmen from the 116th Air Control Wing, Georgia Air Guard, conducted infection control training and procedures in Macon, Georgia, in April 2020. The infection control teams were assigned to work with assisted living facilities throughout the state of Georgia as a part of the Georgia Emergency Management and Homeland Security Agency's efforts to fight COVID-19. (Courtesy of the Georgia National Guard History Office.)

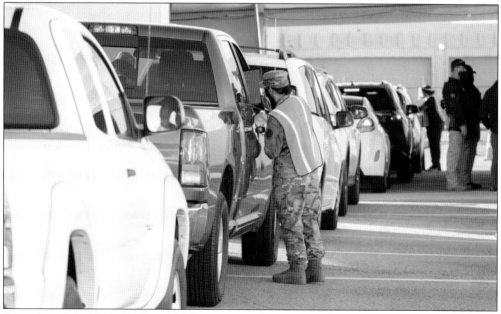

A member of the 116th Air Control Wing reviews information with a citizen at a Georgia Emergency Management Agency (GEMA) COVID-19 vaccination site in Atlanta in February 2021. The Georgia National Guard continued to work alongside GEMA, the Federal Emergency Management Agency, medical professionals, and local law enforcement to minimize the impact of COVID-19. (Courtesy of the Georgia National Guard History Office.)

Many airmen of the Georgia Air National Guard volunteered to serve in response to the coronavirus crisis. These multitalented airmen from various military and civilian career fields stepped forward when their communities needed assistance and earned the respect and gratitude of citizens throughout the state of Georgia. (Courtesy of the Georgia National Guard History Office.)

The 283rd Combat Communications Squadron (CBCS), located at Dobbins Air Reserve Base, participated in annual training in March 2018 with other similar units from the 226th Combat Communications Group (CCG), the 5th CCG, and the 960th Cyberspace Operations Group for a Total Force Combat Comm Rodeo. The pink flamingo is the unit's unofficial mascot. (Courtesy of the Georgia National Guard History Office.)

The Civil Defense Act of 1951 established the Georgia Civil Defense Division of the Georgia Department of Defense. Its primary responsibility was to prepare for the possibility of nuclear attack. Eventually, the role broadened to include domestic emergencies to include flooding, tornadoes, and hurricanes. In July 1981, the Civil Defense Division separated from the Georgia Department of Defense through a legislative act, and it was redesignated the Georgia Emergency Management Agency. Later, the name was changed to the Georgia Emergency Management and Homeland Security Agency. Pictured are early-1970s images of the exterior and interior of the Georgia Civil Defense Division Headquarters building. (Both, courtesy of the Georgia National Guard History Office.)

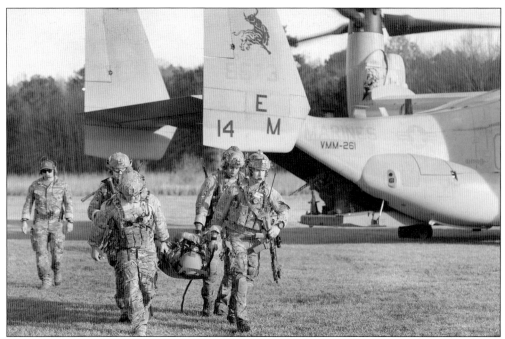

Airmen with the 165th Air Support Operations Squadron disembark a MV-22B Osprey as part of a casualty evacuation exercise in 2020 at Hunter Army Airfield in Savannah. They were training with Marines of Marine Medium Tiltrotor Squadron 261 in shore-based operations in an unfamiliar environment. (Courtesy of the Historical Society of the Georgia National Guard.)

The 165th Air Support Operations Squadron personnel must maintain proficiency in numerous critical skills. Pictured are unit personnel gathered together for a briefing before commencing with live training at the firing range at Fort Stewart, Georgia, in the summer of 2017. (Courtesy of the Georgia National Guard History Office.)

Gov. Brian Kemp of Georgia reviews National Guard and law enforcement personnel on Inauguration Day in January 2019 after he was sworn into office. The Georgia Air National Guard works closely with the Georgia State Governor's Office to provide a safe environment for citizens of the state. (Courtesy of the Georgia National Guard History Office.)

In November 2023, the final E-8C JSTARS jet departed Robins Air Force Base as the 116th Air Control Wing of the Air National Guard and its active duty associate 461st Air Control Wing prepare for new missions. On October 1, 2002, the 116th Air Control Wing was activated, blending Guard and active duty airmen into a single unit. In October 2011, the Active Associate construct was formed with the creation of the 461st as an active duty wing and the 116th as a distinct, separate Guard wing. However, all the while, the personnel have worked cohesively together to carry out the JSTARS mission. With the final plane destined for the military depot known as the

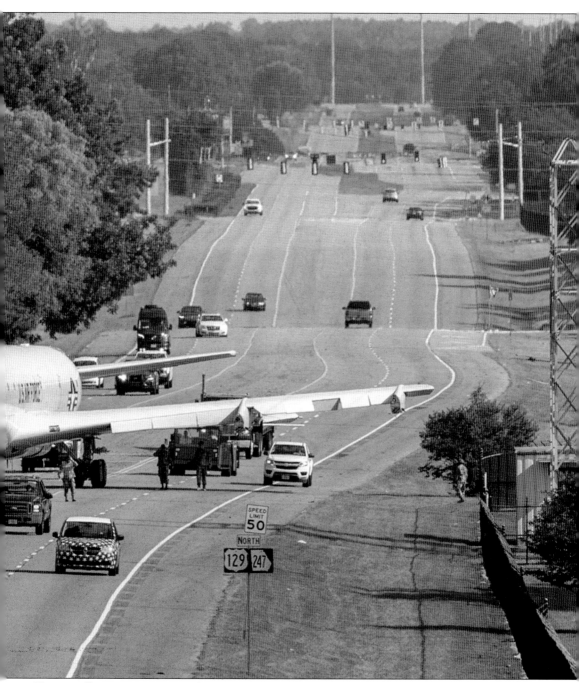

"boneyard" in Arizona, new challenging missions await. Robins Air Force Base will receive a Battle Management Control squadron, an E-11A Battlefield Airborne Communication Node squadron, a Spectrum Warfare group, and support units focused on the Advanced Battle Management System. Pictured is one of the final E-8C JSTARS jets as it is guided along Georgia Highway 247 where it was delivered to the Museum of Aviation in Warner Robins to become a static display exhibit. (Courtesy of the Georgia National Guard History Office.)

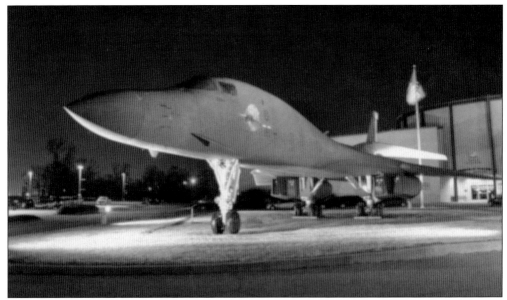

The Museum of Aviation at Warner Robins Air Force Base opened to the public on November 9, 1984, with 20 aircraft on display in an open field and another 20 in various stages of restoration. The museum has grown to become the second-largest museum in the US Air Force and the fourth most visited museum in the Department of Defense. The museum is a place that honors veterans and their families and reminds current airmen of their legendary Air Force heritage. (Courtesy of the Historical Society of the Georgia National Guard.)

The Aviation History & Technology Center in Marietta, Georgia, promotes the exploration of North Georgia's aviation history and relevant technologies through education and engagement to preserve the past and influence the future. It is located less than a mile from the Clay National Guard Center. The staff and volunteers are working to develop the center into a valuable experience for visitors. Pictured is a depiction of the upcoming Legacy Plaza. (Courtesy of the Historical Society of the Georgia National Guard.)

The Mighty Eighth Air Force Museum is a nationally recognized military history museum located in Pooler, Georgia, near Savannah. It documents the role of the Eighth Air Force in the defeat of Nazi Germany during World War II. The Eighth Air Force was organized in Savannah on January 28, 1942. Its mission was the heavy bombardment of strategic and military targets in Nazi-occupied Europe and Germany. (Courtesy of the Historical Society of the Georgia National Guard.)

The World War II Home Front Museum in St. Simons Island, Georgia, opened in 2018. Its mission is to tell the story of the courageous and patriotic Americans who contributed to the victory effort in World War II on the home front in Georgia. The museum is housed in the historic St. Simons Coast Guard Station built in 1936. (Courtesy of the Historical Society of the Georgia National Guard.)

The Civil Air Patrol (CAP) is a nonprofit organization with more than 60,000 members. A component of the Air Force's Total Force concept, CAP performs US inland search and rescue missions. Its volunteers support disaster relief and homeland security missions at the request of various government agencies. Senior members (over 18 years of age) mentor young cadet members in aerospace education and other mission-oriented activities. Many of the cadets later join the Air Force, Air National Guard, or Air Force Reserve. Pictured is a group of Georgia CAP cadets during their summer encampment of 2021 in Savannah where they are boarding one of the 165th Airlift Wing's C-130s for an incentive flight. The one-week encampment consisted of leadership training and team-building activities. (Courtesy of the Georgia National Guard History Office.)

STARBASE is a national Department of Defense youth program designed to increase interest in selected STEM (Science, Technology, Engineering, and Math) topics in at-risk populations. Authorized by an act of Congress, there are currently more than 75 locations in 40 states and territories, with a combined attendance of over 100,000 students each year. Georgia locations are Robins Air Force Base, Savannah, and the Clay National Guard Center in Cobb County, Georgia, as pictured here. Cobb County elementary school students learn the basics of rocketry on the lawn of the Clay National Guard Center Headquarters building. (Courtesy of the Georgia National Guard History Office.)

The legacy of the Georgia Air National Guard and its members reflect the values of the Airman's Creed: "I am an American airman. I am a warrior. I have answered my nation's call. I am an American airman. My mission is to fly, fight, and win. I am faithful to a proud heritage, a tradition of honor, and a legacy of valor. I am an American airman, guardian of freedom and justice, my nation's sword and shield, its sentry and avenger. I defend my country with my life. I am an American airman: wingman, leader, warrior. I will never leave an airman behind, I will never falter, and I will not fail." (Courtesy of the Georgia National Guard History Office.)

BIBLIOGRAPHY

Gross, Charles J. *Prelude to the Total Force: The Air National Guard, 1943–1969*. Washington, DC: Office of Air Force History, 1985.

———. *The Air National Guard and the American Military Tradition*. Washington, DC: Historical Services Division-National Guard Bureau, 1995.

Ridley, Maj. William E., Jr., ed. *116th Tactical Fighter Wing 1941–1983*. Marietta, GA: Georgia Air National Guard, 1983.

———. *Georgia Air National Guard 1941–2000*. Charlotte, NC: Fine Books Publishing Company, 2000.

Willis, Charles A. *A Historical Album of Georgia*. Brookfield, CT: Millbrook Press, 1996.

Discover Thousands of Local History Books
Featuring Millions of Vintage Images

Arcadia Publishing, the leading local history publisher in the United States, is committed to making history accessible and meaningful through publishing books that celebrate and preserve the heritage of America's people and places.

Find more books like this at
www.arcadiapublishing.com

Search for your hometown history, your old stomping grounds, and even your favorite sports team.

Consistent with our mission to preserve history on a local level, this book was printed in South Carolina on American-made paper and manufactured entirely in the United States. Products carrying the accredited Forest Stewardship Council (FSC) label are printed on 100 percent FSC-certified paper.